The Story
of the Tekkieh Moaven

Kermanshah, Iran

Hadi Seif

The Story
of the Tekkieh Moaven
Kermanshah, Iran

Repository of
Early 20th-Century Persian Tiles

Translated and edited by Hamid Kooros

arnoldsche

Table of Contents

I dedicate this book to the spirit of Moaven ol Molk, the founder of this Tekkieh, who died in 1947, and to the deserving and honorable popular artisans who worked there tirelessly. May all of their good deeds remain a testament to history.

Hadi Seif

We decided to mainly keep Farsi names written as pronounced phonetically in this book. There are many variations on how to write these names when transliterating from Farsi to English. Asterisks pertain to terms found in the glossary, pp. 126–138.

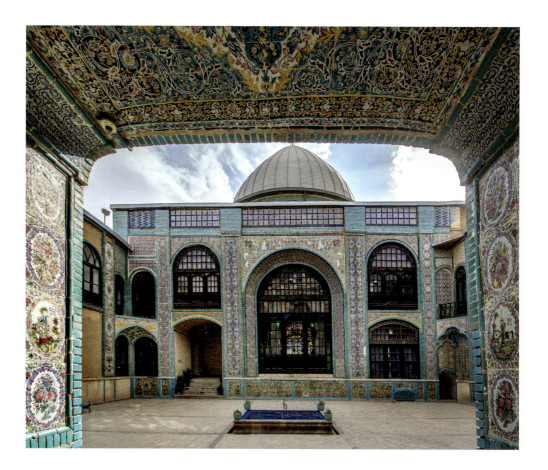

Foreword by Hamid Kooros

Ever since I started collecting tile works in the mid-1970s, I had been looking for books and articles dealing with such works from the late Qajar*/early Pahlavi periods. I found two main sources over the years.

The first scholar I had the pleasure of meeting in the late-1970s was Ms. Jennifer M. Scarce*. She was a rarity since there were many scholars dealing with other aspects of Qajar art but almost no one had approached the study of tile works. Ms. Scarce wrote several important papers over the years on the subject; they are enumerated at the end of this book, in the glossary. She was a pioneer in this field

ABOVE View of the Tekkieh Moaven building and part of vaulted tiled ceiling (Zeynabieh).
LEFT Entrance with verses from the 16th-century poet Mohtasham Kashani (Hosseinieh entry door).

and brought a strong academic approach to the subject. Among the several articles she wrote, she followed the trail of Robert Murdoch Smith, a Scottish engineer stationed in Iran, who supervised the construction of the Iranian part of the London-to-Iran telegraph line.

Murdoch Smith collected both contemporary and ancient Persian artifacts for the South Kensington Museum, now known as the Victoria and Albert Museum (London), as well as for the Edinburgh Museum of Science and Art (Scotland). Part of the contemporary tile works he bought were from a tile maker by the name of Mohammad Ali Esfahani, a subject of Scarce's articles.

ABOVE Religious stylized calligraphic design of a lion and the sun (Zeynabieh).

ABOVE Detail of geometric tile design (Abbassieh).

The other scholar writing about Persian tiles was a gentleman by the name of Mr. Hadi Seif, a native of Shiraz*, Iran. He had written a book in Farsi whose title translates as *Persian Painted Tiles* (Soroush Press, 1997), which I had purchased and which covered different tile makers of the late Qajar/early Pahlavi periods. Mr. Seif interviewed many of the tile makers and their descendants, with Shiraz being the epicenter of this movement during the Zand period (1751–1794), the Qajar period (1794–1925), and the early Pahlavi period (1925–1979).

The combination of the independent studies done by Ms. Scarce and Mr. Seif gave an extraordinary window on that production. We should therefore not underestimate the importance of the tile works by the Shirazis both in Shiraz and in Tehran.

ABOVE Story of Youssef (Joseph) and his brothers (Abbassieh).

In Shiraz, the best known tile maker who straddled the late Qajar and early Pahlavi times was called Mirza Abdol Razzogh*. He was also the head of the guild of the Shirazi tile makers, and he designed many exquisite tile works. Most of the Golestan Palace tile works in Tehran are the work of the original Shirazi tile makers and their descendants, who were invited to Tehran by both Fath Ali Shah Qajar (r.1794–1838) and Nasir al Din Shah Qajar* (r.1848–1896).

These tile makers are said to be direct descendants of a certain Bahram Shirazi, a tile maker during the reign of Karim Khan Zand* (r.1751–1779), whose family descendants can be traced up to recent times. It is interesting to note that once

ABOVE Document and cluster of signatures and stamps (Abbassieh Museum).

their tile works had been essentially completed in the Golestan Palace and the tile makers were spending most of their time on their repair and maintenance, Ali Reza Gholar Aghassi* branched out and started painting on canvas, for which there was a much bigger demand than tile works. The subjects represented on canvas were mainly mythological personages from the *Shahnameh* (Book of Kings) and also religious subjects. This new style became known as the Coffee House* paintings/ style, or Maktab Qaveh Khaneh*.

Another book that Mr. Seif had written was published in 2014 and titled *Persian Painted Tile Work from the 18th and 19th Centuries: The Shiraz School*, published by Arnoldsche, Germany, which I also had the pleasure of sponsoring and translating.

But now let's talk about the present book, *The Story of the Tekkieh Moaven, Kermanshah, Iran*. A Tekkieh is a building where the tragedy of Karbala* is performed with sermons and lamentations; a Hosseinieh* is also a religious building, dedicated to Emam Hossein.

16 ABOVE Vaulted tiled ceiling with stained-glass window (*vitrail*) (Zeynabieh).

It is remarkable that Mr. Seif had the opportunity and foresight to interview the old guardian of the Tekkieh Moaven, Mr. Ebrahim Sojdehpur, in 1992. Tragic events happened in the early years of this Tekkieh (1906–1910), which Mr. Sojdehpur witnessed as a child. His recollection of these events is invaluable. In Moaven ol Molk's days, fights had erupted between two groups, namely the Constitutionalists* and the anti-Constitutionalists, also known as the reactionary forces. As we will see later in this book, the burning and total destruction of the original Tekkieh Moaven instigated by the latter resulted in its reconstruction. Moaven ol Molk decided to use tile works as the main mural decoration, thus replacing paintings, chandeliers, and other artifacts.

Kermanshah was on the pilgrimage road to Najaf, Karbala, and Kazemein in present-day Iraq for Iranian pilgrims, some of whom were tile makers who then decided to spend additional time in the Tekkieh Moaven designing and producing tile works and, ultimately, donating them to the Tekkieh. As a result, this building became a repository of several thousand tile works. Since 1975, it has also been a popular museum visited by hundreds of thousands of people every year.

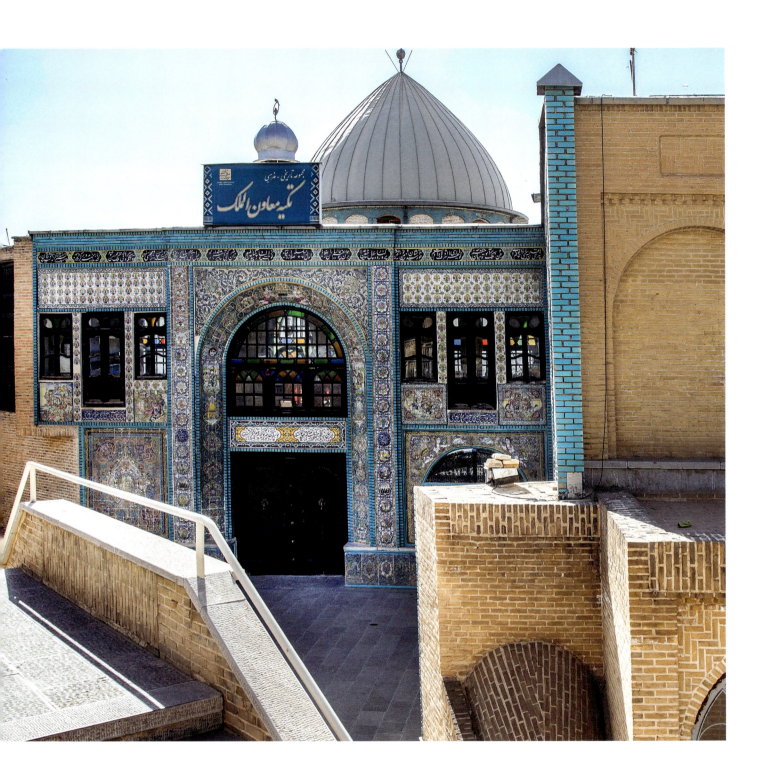

ABOVE View of the entry portal (Hosseinieh).

ABOVE Symmetrical tiled ceiling inspired by carpet designs (Hosseinieh). 19

Introduction by Hadi Seif

||

The story of the Tekkieh Moaven ol Molk, Kermanshah, as narrated by Ebrahim Sojdehpur, its devoted and faithful guardian of many decades.

During the early 1990s I met this old guardian while traveling to Kermanshah pursuing my research on the popular haft rang* tile movement.

He was a short fellow and had a gentle look. He was wearing a black hat and a simple suit and claimed to be fortunate enough to have started working for Hassan

Moin ol Rayaa, better known as Hassan Moaven ol Molk, at a very young age. He witnessed all of the events that happened over the many decades he spent there. His conversation was very personable, and he provided me with invaluable information. It was an eye-opener.

The guardian, Morshed* Ebrahim Sojdehpur, had received a religious education at the Maktab Khaneh, and, in spite of his age and to my astonishment, he answered all of my questions with great detail and clarity, although he was sometimes confused about the dates.

I recorded these conversations on cassette tapes. Today they have an important place among historians and scholars writing about ancient secular and religious buildings. Later on, I was told that Morshed Ebrahim Sojdehpur had died, forgotten. May he rest in peace.

ABOVE Ebrahim Sojdehpur.

ABOVE Calligraphy by Mirza Hassan Khan. Poem by Mohtasham Kashani (Zeynabieh).
Translation: "The heavens started to tremble ... (with excitement)."

The Story of the Tekkieh Moaven ol Molk

||

What follows are the recollections of Ebrahim Sojdehpur in his own words.

I, Ebrahim Sojdehpur, the guardian of the Tekkieh Moaven ol Molk, started working here at a young age for the late Moaven ol Molk to the present day. This Tekkieh was built over 70 years ago, and I witnessed all aspects of its construction and also have many fond memories of the artisans and builders who worked there.

I was educated in traditional religious Maktab Khaneh schooling. I never went to a regular school or high-school, and consequently everything I will be telling you here is the result of my acquaintance with the late Moaven ol Molk and with many other personalities, each teaching me different lessons of life. Everything I will be telling you here is the honest truth.

I am sure that there are many other people much more educated and learned than me who have written detailed accounts of this Tekkieh. I, however, know there is no one who is more familiar with it than me. By the way, it is the second most visited historical building in Kermanshah after the Sassanian bas reliefs* at the Tagh e Bastan site. For this simple reason, please don't compare what I will be telling you now with the writings of other researchers and authors. When writing about me, please mention that this guardian was in love with Emam Hossein* while working among his devotees.

I am very grateful to my father, who was both a religious and social person, for taking me to visit the Tekkieh when I was 11 or 12 years old. At that time, he was in the employ of Moaven ol Molk. This visit happened just before a gigantic fire consumed the Hosseinieh, which I remember vividly.

ABOVE Battle of Karbala (Zeynabieh).

This is what my father told me later on:

"Son, Moaven ol Molk constructed this Tekkieh for the love and devotion he had to Emam Hossein and therefore vowed that every year during the 10 days of the month of Moharram*, during the mourning period for Emam Hossein, the different processions of chest beaters* would congregate here and be served the customary tea and syrup and donated food. During the rest of the year, this Tekkieh was used as a place of prayer." You shouldn't think that this was the first Hosseinieh (which later became a Tekkieh) built in this part of the city called Abshouran*.

I should remind you that it is located in a distinguished and historical part of the city, as are many other religious buildings, such as the Jameh Mosque of Kermanshah, the Shafei Mosque, the Dowlatshah Mosque, and even the Biglar Beigi Tekkieh. Abshouran is an important part of the city because of its proximity to the Kermanshah Bazaar*. Many people are interested in knowing why it is called Abshouran. I am repeating here the sayings of informed people since this story goes back many years. There was a river called Abshouran passing through here, and this is why this part of the city is called the Abshouran quarter now. Let us not forget that in the Kurdish language, Abshouran is pronounced "Tashuvera," whereas in the Farsi language it is called Abshouran.

My late father used to tell me that during the reign of Karim Khan Zand, the governor of Kermanshah was someone by the name of Allah Gholi Khan Zangeneh, who developed and embellished this part of the city with many religious and secular structures such as elegant patrician homes, the Bazaar, schools, and public baths.

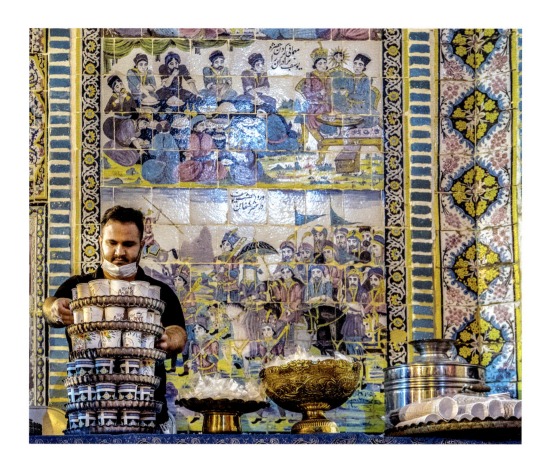

I am responding here to your previous question about why Moaven ol Molk built this Tekkieh in the Abshouran quarter. A satisfying response would be because of the relative importance of this part of the city. A more convincing answer, however, would be based on the location of the Tekkieh itself in the Abshouran quarters; it is located in its heart. After almost a century, this building still radiates like a diamond on the finger of the Abshouran quarter!

Let's return now to the main subject. I remember very well that the first building here was a beautiful Hosseinieh which still shines like a bright picture in my memories. This shows the generosity of the forward-thinking spirit of Moaven ol Molk and, above all, the importance he accorded to Emam Hossein, and this played a very important role in his life.

ABOVE Tea and coffee being prepared during the mourning period of Emam Hossein in modern times.
The tile work depicts the story of Youssef (Joseph) and his brothers (Abbassieh).
LEFT King Soleiman's (Salomon's) court (Abbassieh).

27

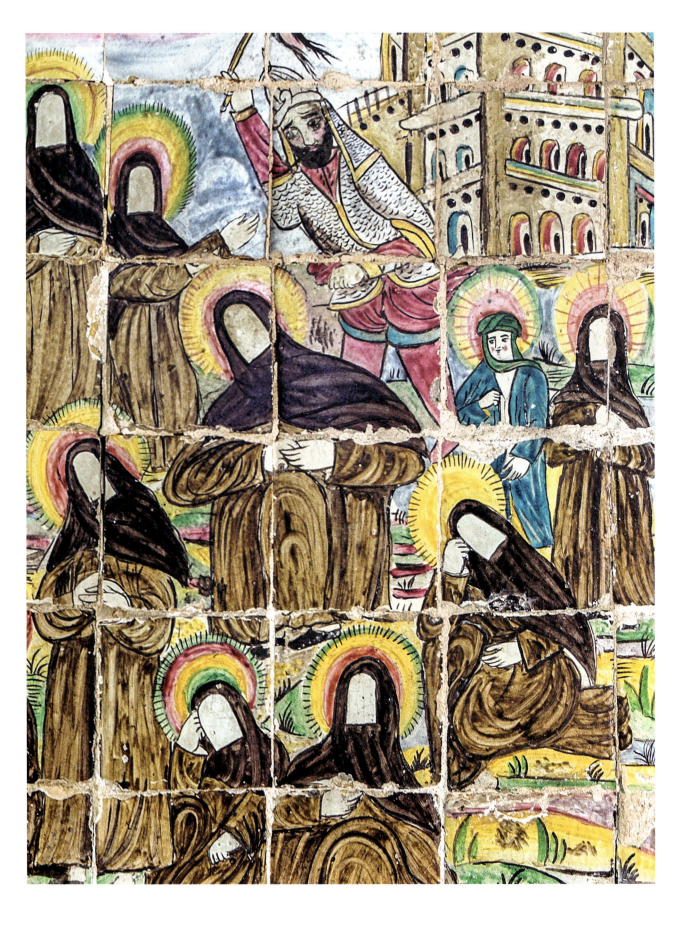

ABOVE Detail of tile work on opposite page (Zeynabieh).

Since Moaven ol Molk was very well off financially, he bought and mounted attractive chandeliers that would bring joy when turned on. He also covered the floors of the Hosseinieh with beautiful carpets and hung expensive candlesticks on its walls. Moaven ol Molk had originally built a two-story building with ample space and with several rooms decorated with beautiful mirror works. Without exaggeration in the history of Kermanshah and maybe that of the whole country,

there was no Hosseinieh that could rival its beautiful mirror works. It looked like a royal palace.

People just loved this Hosseinieh! They would come here to solve their disputes by asking Moaven ol Molk to act as their mediator and peacemaker. You would sometimes see, for example, members of a tribe by the name of Songhar* descend here because of an internal dispute they had. They would all congregate and meet with Moaven ol Molk, who in turn would welcome them and then solve their dispute. This is also true for many other tribes as well as for city dwellers.

ABOVE Hazrat Qasem (Emam Hossein's son-in-law) in the battlefield during the Battle of Karbala.

Mr. Seif, you previously asked who were the builder and the mirror makers* of this Hosseinieh.

I was too young to remember the previously mentioned sad events that took place in this Tekkieh; I will give you here the information provided to me by my late father, who would always mention to me Ostad Asghar Me'mor, better known by everyone else as Ostad Me'mor Bashi*. I met Ostad Me'mor Bashi after the infamous fire because of the close relationship he had with my father. They would also visit each other's homes.

ABOVE Symmetrical floral tile panel with medallion in the center (Hosseinieh).
RIGHT Detail of medallion shown on panel on the left (Hosseinieh).

ABOVE Hazrat Ali Akbar in the battlefield.

Me'mor Bashi was a pious person; he would always wear a white round cap and carry a bag made out of fabric that contained construction measurement tools, a pencil, and instruments used for drawing and designing.

My father would say that all of Me'mor Bashi's know-how and experience came from the time he actually spent on the job, in the middle of dirt, bricks, and gypsum. Contrary to today's architects and builders, he never studied architecture or engineering, and he didn't pretend he had. He started his career as an apprentice builder and gradually became the best in this field.

As told by my father, toward the end of his reign, the king Nasir al Din Shah Qajar granted him the title of Me'mor Bashi after he had built an impressive patrician's house. He was highly qualified and unrivaled in his field.

After Me'mor Bashi constructed the Hosseinieh, he introduced Abol Ghassem, a mirror maker from Shiraz, to Moaven ol Molk, who in fact was also a friend of my father, as they had worked together on several patrician houses in Tehran. Since Moaven ol Molk always liked new ideas, he also invited Mirza Ahmad, the mirror maker, to join them; in the past Mirza Ahmad had decorated the Dar ol Sanaye Nasseri* structure in Tehran. It is unfortunate that we didn't have the capabilities of photographing the very precise and skillful art works of these two artisans at the time. This would have helped us to understand why Moaven ol Molk decided to decorate the Hosseinieh with beautiful mirror works.

We should also not forget of all the work done by the diligent woodworkers who built the window frames, on the inside of which glasses of different colors illuminated the Hosseinieh. I quote my father here again. The most important woodworker who worked here was Seyed Sharif Najar. He started with the construction of the windows of the Hosseinieh and then with those of the Zeynabieh* and finally those of the Abbassieh*. He could design and execute all of the geometric shapes while making sure they were properly placed in their respective frames. He would use a calibrated piece of wood to help him calculate and design the different shapes needed. Mr. Seif, you asked me previously, how did this Hosseinieh burn down?

Although I was very young and inexperienced at the time, I will give you my personal recollection of these events.

As I had mentioned before, the Hosseinieh was a pleasant gathering point not only for religious purposes but also as a social meeting place.

ABOVE Mollah preaching from the mambar (pulpit) (Zeynabieh).

As the movement of the Constitutionalists was growing in importance, they chose the mosques as gathering places, and this is where they confronted the reactionary forces chanting revolutionary slogans. As time passed, the Constitutionalists also gathered in the Hosseinieh, and slowly but surely it became their favorite meeting point. People from all classes and backgrounds were gathering at the Tekkieh Moaven, where they would fiercely fight the reactionary forces. Well-known religious figures, Mollahs*, and bazaar merchants joined them later on in their fight. The Mollahs would preach from their mambars* (pulpits) and get the crowd stirred up.

ABOVE Stylized details of dragons, lion heads, birds, grapes, and vines.

Moaven ol Molk offered them all of the Hosseinieh's facilities and services, and this included serving them tea and syrup and even sometimes lunch and dinner. Certain well-known merchants would also financially contribute to this cause.

It was only natural for the governor, the city authorities, and the reactionary forces to be upset by such gatherings. They decided to set the Hosseinieh on fire with the intention of completely destroying it. At that time, a certain Zahir ol Molk Zangeneh* was the governor of Kermanshah. He was old, judgmental, and a recluse. He wanted to teach the Constitutionalists a lesson by setting the Hosseinieh on fire.

ABOVE Geometric tile designs above a passageway (Zeynabieh).

Here are the details of these events:

I remember very well that around noon time on a Friday*, the Hosseinieh was packed with women and men of all ages when suddenly the soldiers of Zahir ol Molk started their attack by beating the crowd. The sound of the screams and cries of that day still resonate in my mind. As an additional act of cruelty, Zahir ol Molk started bombarding the Hosseinieh while his soldiers were firing at the crowd. Many innocent people were hurt, bled, and died or were trampled under the feet of a terrified crowd.

Zahir ol Molk was not satisfied with this crime alone; he then ordered his troops to set the Hosseinieh on fire. This beautiful Hosseinieh was consumed in two or three days, and who could have imagined that all of these chandeliers and mirrors would be completely destroyed?

My father said Zahir ol Molk Zangeneh also had a deep personal grudge against Moaven ol Molk, and he was not just satisfied with just setting the Hosseinieh on fire, he then sent his hoodlums to plunder Moaven's beautiful personal home and set it on fire, too. Terror and panic engulfed the city and everyone was wondering how Moaven ol Molk and the Constitutionalists would react.

Did Moaven ol Molk actually respond?

The answer is yes, he did respond. Was it possible for him to remain silent after having witnessed the destruction of both the Tekkieh Moaven and his personal house? Let's also not forget the injuries and loss of lives inflicted on innocent people.

The authorities were preparing themselves for a full-fledged war. At this stage, the clerics and the scholars together with some prominent citizens declared a temporary truce and asked Moaven ol Molk to cool down; they didn't want to see more bloodshed during these delicate and uncertain times.

As my father continued telling me, Moaven ol Molk found refuge with the Songhar tribes, where he had many friends and sympathizers. The heads of these tribes prepared themselves for a confrontation with the forces of Zahir ol Molk Zangeneh. Many Freedom Fighters from other adjoining towns and villages of the Province of Kermanshah also joined Moaven ol Molk in this fight.

Do you still remember the amount of damage caused by the bombardment and fire of the Hosseinieh?

Of course, I remember that not a single mirror work survived and that all of the different rooms also suffered major damage. In addition, all wooden doors and windows were completely destroyed. You had a similar situation at Moaven ol Molk's house. To summarize the situation, all we had left was a mountain of rubble.

ABOVE Passageway with a panel featuring Hazrat Abol Fazl (Abbas)*, the half-brother of Emam Hossein 43
bringing water from the Euphrates river to Emam Hossein's family (Hosseinieh).

ABOVE Interior courtyard of the Tekkieh Moaven decorated with tile work (Hosseinieh).

My father would then comment on it sarcastically.

The Hosseinieh and Moaven ol Molk's home were used as sacrificial lambs, since less than a year after these events the Freedom Fighters (Constitutionalists) were victorious and Mozaffer al Din Shah Qajar* declared and approved a new Constitutional Monarchy in 1907 for the country.

I would not have been a Constitutionalist if the cost of fighting the reactionary forces would have been the destruction of hundreds of structures similar to this Hosseinieh. I will also give you this additional piece of information about my father.

After the victory of the Constitutional Revolution*, Moaven ol Molk told his closest friends that there is no sweeter revenge than the adoption of the Constitution by the country and the liberty it provided to its people. It was a good thing that the cool-headed leaders of the city were able to prevent a full-fledged war.

The first time we met, you told me about the destruction of both the Hosseinieh and of Moaven ol Molk's house; could you now please tell me what happened afterward?

Yes, since I was at that time accompanying my father, who was employed by the Moaven ol Molk organization, I will tell you in detail how the Hosseinieh was reconstructed later on. Again, as told by my father, Moaven ol Molk asked Me'mor Bashi to start reconstructing the Hosseinieh about a year after its destruction.

As it looked originally?

Not at all, since Moaven ol Molk observed that the mirror works were not durable enough and could be damaged easily even if there was no fire.

Moaven ol Molk then asked this of Me'mor Bashi:

"Me'mor Bashi, you have to think of a different way to decorate the Hosseinieh, in a way that neither the cold nor warm weather would damage it."

Me'mor Bashi, who was experienced and well-traveled, proposed to decorate the Hosseinieh with haft rang tile works, and this idea pleased Moaven ol Molk a lot.

Dear Mr. Sojdehpur, did Kermanshah produce any tile works at that time?

No, it didn't produce tiles like they had in Tehran or Shiraz, but I would venture to say that Moaven ol Molk had seen and heard that many of the palaces and patrician residences of Nasir al Din Shah Qajar's era were decorated with such artifacts. He therefore quickly accepted Me'mor Bashi's proposal. Let's not forget that tile makers and tile designers were very much in demand then.

Which tile makers accepted this responsibility?

Since Me'mor Bashi had spent some time in Tehran working with other builders and tile makers in the past, he had a close relationship with a certain Hassan Naghash Tehrani, whom he introduced to Moaven ol Molk. Hassan Naghash Tehrani brought along another tile designer by the name of Seyed Abol Ghassem Mani. As both tile makers were highly regarded and masters in their own field, it was then decided to persuade Moaven ol Molk to add more buildings to the present Hosseinieh, and preparations were made for the construction of the Zeynabieh and the Abbassieh buildings.

They first started with the construction of the Zeynabieh, a two-story building with some rooms located in the center of it.

Why a two-story building?

It is obvious why, since the Tekkieh was not built for the attendance of men only, but for women also. Both men and women would participate in the different mourning and other religious ceremonies.

ABOVE Spandrel showing two angels holding a crown (Hosseinieh).

وارد شدن اهل بيت مدينه طيبه حسن كاسى پز طهرانى

48 ABOVE The arrival of the faithful in the city of Medina. Signed by Hassan, a tile maker from Tehran (Zeynabieh).

We therefore had to take into consideration the safety and comfort of the women. This is why a second story was built in the Zeynabieh: it allowed women to be at ease and far from the prying eyes of non-family members. Me'mor Bashi and his friends also started the construction of the Abbassieh at about the same time, and this building had very tall walls. The Abbassieh had two entrance doors connected to two sloping alleys which in turn led to two streets called Moaven ol Molk Street and Ilkhani Street.

Did Me'mor Bashi build two doors on purpose, in order to ease the congestion of the participants?

In addition to these two doors, he also opened a third door, leading to a street called today Hadad Adel Street.

Why did he build all of these entry and exit doors?

Please take into consideration that when any devout and God-fearing builder would be offered a job, he would first consider the well-being and comfort of the people. The same logic was used when building traditional homes, where you had an Andaruni* serving as the private quarter of the home and a Biruni* used as a social and public entertainment quarter. These two sections were connected to each other but served two different purposes.

This same system was also used in religious buildings. As you can see, most of the mosques have many different doors leading often to different streets.

Concerning the Tekkieh Moaven ol Molk, Me'mor Bashi planned from the start that each group would have its own entry and exit doors, since several religious and mourning processions would take place simultaneously. This is especially true for the 10 days of the month of Moharram, during which you would make sure that people would not trample on each other, get hurt, or fight each other.

I witnessed how during the Ashura* day the different processions entered and left the Tekkieh in an orderly manner.

What about explaining to us now how the tile decoration process worked for the Hosseinieh, the Abbassieh, and the Zeynabieh?

First of all and before I forget, I would like to mention a friend of Haj Hassan Ostad Kashipaz Tehrani. I was told that he was originally from Tehran and that concerning his tile works he was a very talented and a well-known artisan.

I am referring here to Ostad Minachi*. It is thanks to him that we were able to preserve many of these unique haft rang tile panels.

I wanted to ask you, Mr. Sojdehpur, before we go into too many details, how did you choose the different subjects depicted on your tile works?

Did the tile makers choose their own designs or were the orders placed with some specific designs in mind by their respective patrons?

It is good question. I would like to remind you that the Tekkieh Moaven ol Molk was not built just to be a decorative building or an ornate structure. It was primarily a religious building for the usage of the pilgrims on their way to Karbala, where they would visit the tomb of Emam Hossein. Since the 10 days of the month of Moharram were celebrated here, people had to first be acquainted with religious stories, and especially with that of the tragedy of Karbala.

The late Moaven ol Molk was very sensitive on this subject. He would not allow the tile makers to produce any tile works unless first approved by him.

My late father would tell me that Moaven ol Molk was in constant touch with the religious establishment and the Olamas* and would not allow the production of any tile works unless he had their previous written or verbal approval. This showed his wisdom.

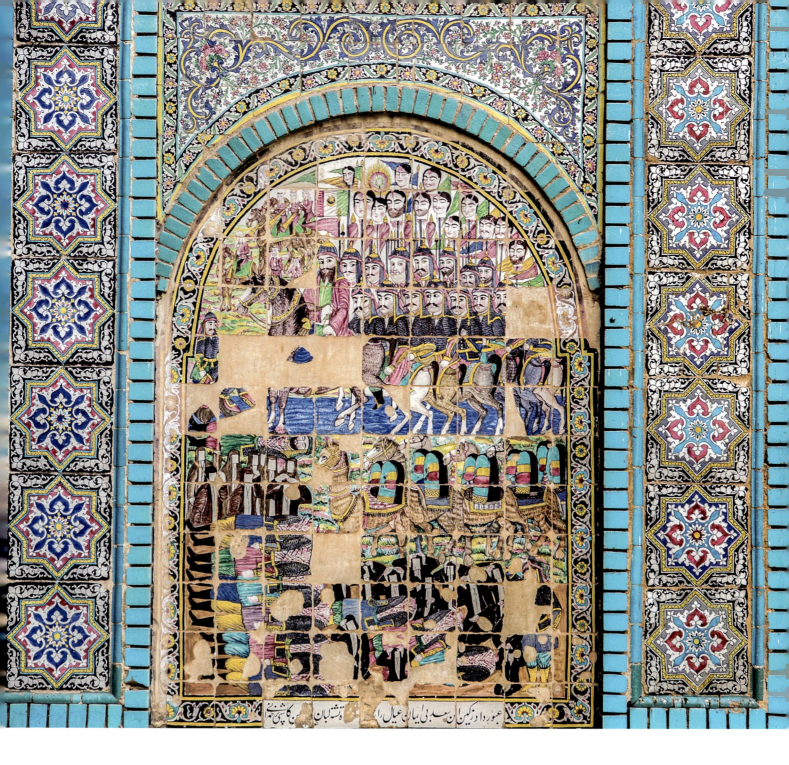

ABOVE The Battle of Karbala, tile work signed by Hassan, a tile maker from Tehran.

ABOVE Chest beaters during a procession on the Ashura day (Zeynabieh).

Don't you think that many of these designs didn't fit here?

You are correct, I fully agree with you, but even in these circumstances, we will have to respect Moaven ol Molk's choices and taste, and I will tell you why.

Even if we do not take into consideration his devotion and faith in God and his love for Emam Hossein, Moaven ol Molk was an enlightened person and, as you said, also very "open-minded" for his time. As my father would say: "There is nothing wrong in acquainting people with their own culture, with important historical figures, and with the Olemas." These designs were done as an addition to the traditional religious themes.

I would like to mention to you, Mr. Sojdehpur, that there are many non-religious themes on the tile works. For example, there are depictions of different kings of Ancient and pre-Islamic Iran, of flowers and birds, of the Olemas, and of well-known personages; there is even a Rowzeh Khani scene!*

People also appreciated beauty and the colorful flower designs in addition to the more traditional religious themes. You have to agree with me that you needed someone with a lot of courage and an open mind for displaying such a novelty in this Tekkieh. Even during those times, many people complained about his decisions, but Moaven ol Molk would not easily give in to their baseless objections. He strongly believed that for people who didn't have easy access to books, these different historical themes were the best way to educate them.

As Moaven ol Molk was saying, "I hired many talented and pious artisans; I knew that they will execute their work professionally. On top of that, I wanted to leave my own small legacy for future generations to enjoy and for people to fondly remember me."

This is exactly what happened; the Tekkieh Moaven is now one of the most important buildings in the city of Kermanshah. Visitors coming here are both foreigners and locals, since this Tekkieh plays the role of an open book where they are acquainted with religious stories as well as Iran's history.

Mr. Sojdehpur, the execution of all of these artworks must have required a lot of preparation and hard work by the tile makers, woodworkers, and, most importantly, the builder himself? What do you remember of these talented artisans?

You are absolutely right. The builder Asghar Aghaye Me'mor, better known as Me'mor Bashi, drew the plans and constructed this Tekkieh. I had heard but had not personally seen that this gentleman had in the past built one or two mosques in Tehran before he started the construction here. He used to live in Tehran, where he did an excellent job. It was only natural for Moaven ol Molk to entrust the construction of the Tekkieh to such an experienced builder. You know perfectly well that experienced and traditional builders were also well traveled.

ABOVE Representation of peace and friendship between two kings (Ancient Iran) (Zeynabieh).

ABOVE Scenes of pre-Islamic Iran and pictures of ancient kings (Zeynabieh).

55

شاهزاده فرمانفرما
عبدالحسین میرزا

They would always respect the primary character of any building and make it easy for people to enjoy; this applies to religious, residential, Zur Khaneh* (traditional gymnasium), and Hammam* (bathhouse) buildings as well.

I had heard that when a traditional builder started a new construction, he would be very diligent in his work, and toward the end of the construction the client would accept him as a family member. For starters, when the builder would access the property of a new client, the first step he would take was to build a small room for himself where he would stay two, three, or sometimes five years. For anyone staying anywhere for that long, it is only natural that he could not leave such a place or such a house without a heavy heart.

The neighborhood often named a street after a builder, since they didn't consider him to be a stranger anymore. Our Me'mor Bashi was a long-term resident of the Tekkieh, both prior to and after the big fire. He was constantly improving his work and was fully devoted to it. I remember that Me'mor Bashi always had a strong presence in the Tekkieh, and we would sometimes ask ourselves who the real boss was, Moaven ol Molk or Me'mor Bashi?

He would also give his opinion and question the work of the other artisans. My father remembered once hearing a heated argument taking place between Me'mor Bashi and Moaven ol Molk, probably related to money matters. Me'mor Bashi was saying fearlessly to Moaven ol Molk:

"Do you really think that I am spending my days and nights building this Tekkieh for a pittance? I strongly believe that I will receive my wages somewhere else. Emam Hossein will pay my wages and the wages of people like me on Judgment Day*. I do this work for the love and devotion I have for our martyr Emam Hossein."

You can observe here Me'mor Bashi's strong faith; he worked tirelessly, day and night. Anywhere you look, you can see his work done very meticulously. He also used sparingly all the available space for the construction of this Tekkieh. Even when he had to build a set of 17 additional steps near one of the entrances, he decided to erect a Sagga Khaneh* (public water fountain) next to it for people to quench their thirst.

Mr. Sojdehpur, please tell us now about the tile makers and the tile designers.

I don't know where to start, since they all were exceptional masters in their own right. For example, Haj Hassan Kashipaz Tehrani*, after having accepted the job, decided to immediately build a kiln. He went to Feiz Abad*, a part of the city close to the Tekkieh where he constructed a temporary kiln for the firing of his tiles. However, he wasn't used to working alone. Similar to an army general, he had a whole group of people working alongside him, and these included the kashisab (tile grinder/grater), the gholebkar (tile molder), naghash (tile designer), and kourehban (kiln supervisor).

The way this process worked was for Haj Hassan Kashipaz Tehrani to approach Moaven ol Molk in order to have his final assent on a certain design that had been pre-approved by the religious establishment. He would then gather his crew and discuss the preliminaries of the work. Afterward, they would pencil the design on a transparent roll of paper.

ABOVE Typical representation of one of the Olemas (priests) (Abbassieh).

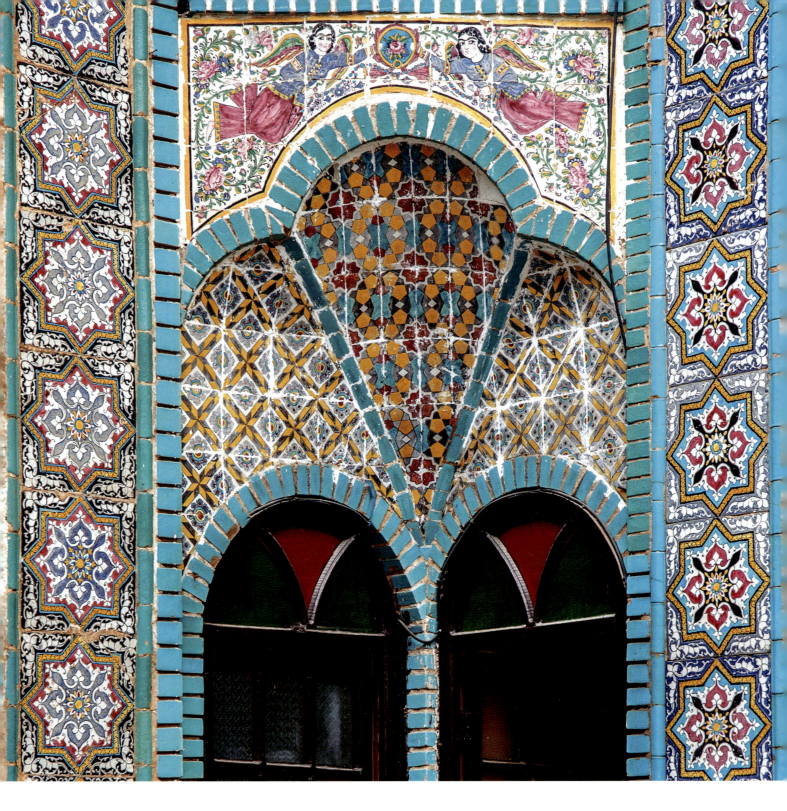

ABOVE Spandrel with two angels holding a flower ring.

Then, in order for Moaven ol Molk to make sure that the designs were fully compliant, he would show them to his friends in the religious establishment for their final approval. Should they have a question or comment, Moaven ol Molk would relay the message immediately to the artisans, such as Haj Hassan Kashipaz Tehrani, Abol Ghassem Mani, and Minachi, to name just a few.

Haj Hassan Kashipaz Tehrani's reputation was as good as Me'mor Bashi's. Without exaggeration, he could draw in a very short time a thousand horse riders and soldiers on a single piece of transparent paper.

So, what was Abol Ghassem Mani's job then?

May God bless his soul, he was a very gifted tile maker. His colleagues would call him Abol Mani, and he was a real Mani* of his time.

Just don't underestimate him; he was such a gifted tile maker that even Haj Hassan Kashipaz Tehrani would never have dared firing his tiles without first consulting him. In addition to his deep knowledge of religious stories and themes, Abol Mani was an educated designer and an avid reader. He was also very knowl-

edgeable in history in general, and for this reason he could easily design the portraits of kings, of the Olamas, and other important personages.

He was a modest, humble, and quiet person, and every time you would consult with him, be it in his design shop or in his room in the Tekkieh, you would see him drawing different motifs on transparent paper.

How was the relationship between Haj Hassan Kashipaz Tehrani and Abol Mani? Were they competing with each other?

No, sir, absolutely not. These traditional Masters would never think that way; this was not in their character. They were very close to each other and thought the same way. They would spend more time on helping a colleague's design than on their own. This type of jealousy or competition is prevalent among today's designers. All of the traditional and previous generation's designers, on the contrary, would work for the love and devotion they had for Emam Hossein.

ABOVE Detail of standing darvish holding a kashkoul (beggar's bowl) and a tchomogh (wooden stick) (Abbassieh).
LEFT Representation of darvishes (Abbassieh).

ABOVE Tile depicting Hassan Moaven ol Molk's tomb (Zeynabieh).

I remember once that Haj Hassan Kashipaz Tehrani didn't design the legs of a horse with the proper dimensions on a transparent piece of paper; this may have been due to the density of the people and objects being represented there.

I witnessed how Abol Mani spent a whole day redrawing the horses and their riders. He sometimes would do this without even asking the original designer for his consent. Since people would sometimes criticize the works of a certain designer, this would tarnish all of his works. This is especially true for artisans who had been friends forever; they would sacrifice everything for each other.

A friendly relationship existed between Haj Hassan Kashipaz Tehrani and Abol Ghassem Mani, and a little while afterward they invited Mr. Minachi to join them, since their designs were very condensed. Mr. Minachi was a real jack-of-all-trades, knowledgeable in many fields such as tile making, tile designing, and even construction! Most importantly, he was an Esfahan native*, a city where most of its citizens were art lovers. You can then see how strong a team of a tile masters was assembled.

Do you think that these master tile makers had much variety in their designs?

As you can see, there is a wide variety of designs in the Tekkieh Moaven ol Molk which include the embossed [tiles], semi-embossed tiles, and many different tile panels decorated with a mosaic border. These tile panels were made about a hundred years ago, and when you look at them, they seem to be coming fresh out of the kiln, and the main reason for this beautiful appearance is that the tile makers used only natural and long-lasting dyes.

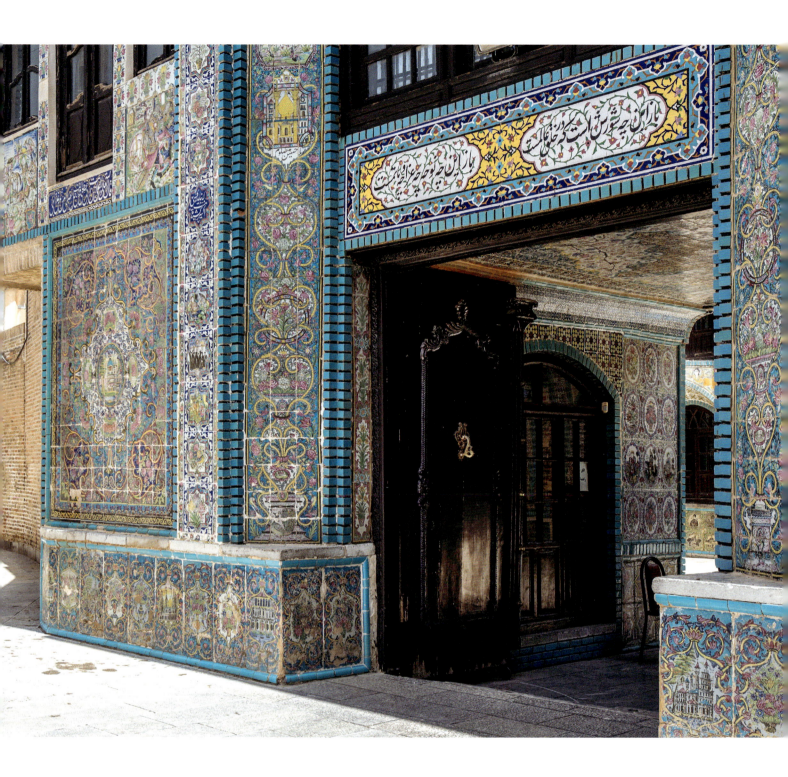

ABOVE Verses from the Safavid-era poet Mohtasham Kashani (Hosseinieh).

With all these beautiful tile panels, please tell us, what are the main subjects depicted here?

I have to admit that the tragedy of Karbala was the main subject, and I will tell you why a little bit later.

Why later, Mr. Sojdehpur, why not now?

First for their love and devotion to Emam Hossein, second for their faith, and third for all of the sacrifices made by these artisans who sometimes were pilgrims on their way to Karbala, and this needs in itself a lot more explanation.

Did you have other tile makers involved in addition to the ones you mentioned previously?

I wanted to share this before with you, but since you mentioned it, I will do it now. As I explained previously, Moaven ol Molk built this Tekkieh not only as a place for mourning Emam Hossein but also as a hostel where pious pilgrims could spend some time on their way to Karbala.

They would stay in the different rooms and also be served breakfast, lunch, and dinner, and all of this would be paid for by donations and pledges made by pious

ABOVE Verses by Mohtasham Kashani, a poet from the 16th century, stating, "What is the tumult now among the world creatures? What now is this wailing, this mourning, this lamentation?" (Hosseinieh). SOURCE: ENCYCLOPEDIA IRANICA. Mirza Hassan Khan, calligrapher.

69

ABOVE Detail of flowers and birds of the panel on the right (Zeynabieh).
PREVIOUS PAGES Ceiling tile work with symmetrical design and with floral motives similar to a carpet design (Hosseinieh).

people. For this reason, the basement of the Tekkieh was always full of bags of rice, cooking oil, and other necessities.

You would sometimes recognize a well-known artisan traveling with his family among the pilgrims passing through here, and they would often think of leaving a nice relic of their own while looking at all of the tile works done by others. We had a painter who during his stay here decided to paint all of our flower pots; there was a woodworker who also decided to work and came to the help of our own woodworker, Haj Mirza Najar.

Artisans would often donate their artworks to the Tekkieh, and for this reason the Tekkieh Moaven was not only a religious destination; it also gradually became an art center.

ABOVE Triptych tile work depicting King Shahpur of Ancient Iran (Zeynabieh).

73

ABOVE Enlarged medallion from the panel to the left.
LEFT Polychrome wall tile panel with a medallion showing European style architecture.

Dear Mr. Sojdehpur, what about the tile works? Did any of the haft rang tile makers leave any artifacts here?

Yes, you've asked a good question. You will find the traces and creativity of many tile makers. It took approximately five years from its destruction for the tile makers to design and decorate the newly redone Tekkieh. A well-known tile maker by the name of Ali Reza Gholar Aghassi, who was working out of a workshop named the Shirazis Tile Makers Workshop, located in the Tekkieh Manuchehri* in Tehran, decided as his religious duty and for his devotion to Emam Hossein to make two tile panels depicting some of the stories of the tragedy of Karbala. Unfortunately, since I am not really familiar with his works, I was not able to distinguish them from that of the others.

But now let's talk about Hossein Gholar Aghassi*, the son of Ali Reza Gholar Aghassi, who came about 20 years after we had finished decorating the Tekkieh. He was passing through here, and we really have to compliment him for the tile works he did and which you are now able to admire.

ABOVE Spandrel showing two angels holding flags with incantations to Emam Hossein (Zeynabieh).

Yes, I did see his works, and it is worthwhile mentioning that the custodians of Emam Hossein's mausoleum even invited him to come to Karbala (Iraq) at their expense in order for him to decorate it; they were familiar with his works, both on canvas and on tiles.

It is important to note that Hossein Gholar Aghassi was a devout person and our guest here while on his way to Karbala. He came here with a young apprentice by the name of Mohammad Farahani*, and before I continue telling you about Hossein Gholar Aghassi, do you know who this apprentice was?

Yes, of course, I know him well; he was named Mohammad Farahani, and he later designed subjects on very large curtains used by the darvishes during the Tazzieh* ceremonies, known as Darvishes' curtains. He did such beautiful designs that we could call him a propagator and promoter of this art form.*

Mohammad Farahani is still alive today; he is in his fifties and still continues to paint. I am glad that you know this talented young artist.

As I was saying, I once met a young distinguished pilgrim among the other pilgrims who intended to stay 10 days here and then continue his pilgrimage toward Karbala. At the time, I wasn't aware who he was or of his art; he was named Hossein Gholar Aghassi, who while admiring our tile works became very emotional and asked the people responsible if he too could design some.

He stayed here a full month instead of his planned 10 days, and he, together with his apprentice Mohammad Farahani, built a temporary kiln inside the Tekkieh and later designed some beautiful tile panels which we installed on our walls.

Dear Mr. Sojdehpur, can you recognize them and show them to us?

Of course, I can recognize his works, but unfortunately they were not signed. This lack of signature was done on purpose. They did so because they didn't want to be pretentious or ostentatious. It was their hearts and faith that directed them to create these artworks. And it is for this same reason that Hossein Gholar Aghassi didn't sign any of his works here, either. It is very possible that he would as a general rule sign a painting or tile work depicting a king or some unknown character, but here in the Tekkieh he and the others wouldn't sign their works when depicting the tragedy of Karbala.

I remember the late Hossein Gholar Aghassi as a happy and sociable person, this in spite of him working hard and non-stop from early morning till late afternoon. He always had a smile on his face.

ABOVE Geometric design with floral detail (Abbassieh).

80

ABOVE Battle of Karbala showing Emam Hossein and Abol Fazl (Abbas) fighting the enemy.
Signed by Mohammed Hassan, a tile maker from Tehran.

81

ABOVE Window detail above an entrance door (Hosseinieh).

LEFT Floral tile details with a sun face and angels.

Did Hossein Gholar Aghassi receive any compensation for his work?

No, he didn't. The only expenses reimbursed to him were for the wages of his apprentice, Mohammad Farahani, and for the dyes and other tile-making* materials he had bought. I remember people asking him, why shouldn't you get paid since making tiles is your actual profession?

Please listen carefully to his answer: "I will be paid on Judgment Day by a satisfied God and by the intervention of Emam Hossein, and these wages are not comparable with mountains of money or vessels of gold coins." As you can see, this Tekkieh was built by pious artisans and for the love and devotion they had to their faith. You cannot put a monetary value on this.

With the exception of Hossein Gholar Aghassi, do you remember any other artisans who worked here for their love and faith and who also left some of their tile works here?

I am really getting old and have lost some of my memory; I wish you had asked me this same question 30 or 40 years ago and then I would have remembered all of their names.

ABOVE The three tile panels shown here are situated above an entrance door. The central panel is religious Arabic calligraphy with verses from the holy Quran (Hosseinieh).

I remember that the Tekkieh was hosting the Shirazi tile makers many years ago. You probably know that after the Constitutional Revolution of 1907, there was a Shirazi tile maker by the name of Mirza Abdol Razzogh, who, with the help of another tile maker, established a tile workshop in an old part of the city of Kermanshah. They also designed tiles for the decoration of many different buildings, such as individual homes, mosques, Tekkiehs, Hosseiniehs, Zur Khanehs, Sagga Khanehs, and even Hammams. He was a short fellow, very smart and with good taste. He, too, was a pilgrim on his way to Karbala and spent some time here at the Tekkieh. When realizing that his colleagues had designed such beautiful tile works, he decided to start designing his own.

ABOVE Dome with black-and-white tile panels and calligraphy from the poet Mohtasham Kashani. The calligrapher is Mirza Hassan Khan (Zeynabieh).

Mirza Abdol Razzogh had a friend in Hamedan* called Mirza Jalal Kashipaz Hamedani*. Apparently, Mirza Abdol Razzogh traveled to Hamedan to Mirza Jalal's tile workshop and made several tile panels depicting flowers and birds over there and then brought them back here and donated them to our Tekkieh.

Did you have any empty walls where you could install these tile works?

Yes, of course. We still had a few empty walls in the Hosseinieh, Zeynabieh, or Abbassieh.

How was Mirza Abdol Razzogh's work?

Without any exaggeration, Mirza Abdol Razzogh's flowers were comparable with real flowers, their only difference being that they didn't emit any scent. Since he had made these tile works with a lot of love and passion, nothing was missing.

Do you remember other tile makers, such as the late Mohammad Modaber and Haj Bagher Jahanmiri*?*

Truthfully, I don't remember them, but their names seem familiar, especially Mohammad Modaber. I really don't know if the Tekkieh had any of their works.

ABOVE Black-and-white panel representing the story of Gadir Komm* (Zeynabieh). 87

ABOVE Alcove inside the Tekkieh Moaven.

Sir, I saw some tile works depicting the Persepolis stone works which were similar to Forsat ol Dowleh Shirazi's* stone prints (Tchop Sangi*) in his famous book* Assar va Ajam* *(The Works of Ajam).*

What type of question are you asking me? I can hardly read or write. How should I know who Forsat ol Dowleh was or about his book *Assar va Ajam?*

I only remember that after a tile panel about Ancient Iran was made and inspired from the *Assar va Ajam* book, an educated and worldly gentleman wearing metal-rimmed glasses, walking with a cane and wearing a Sardari* came here. He sat down with Moaven ol Molk to an enjoyable meeting. People were saying that this gentleman was very educated and was from Shiraz. His intention was also to do a pilgrimage to Karbala, and I remember that Moaven ol Molk respected him a lot. I really don't know, however, if this person was Forsat ol Dowleh or someone else.

I am sure it was Forsat ol Dowleh because we have pictures of him, and he looks exactly the way you are describing him.

Haj Mohammad Reza Kashipaz Shirazi stayed here for a whole summer, spending most of his time with Me'mor Bashi and Haj Hassan Kashipaz Tehrani. He didn't do any new tile works, but he repaired many tile panels, and after being done he and his family left us in order to carry on with their pilgrimage to Karbala.

Sir, this Tekkieh had many other artisans involved in addition to the tile makers we talked about. We had builders, other tile makers, painters, carpenters, stone carvers etcetera, but unfortunately I don't remember their names.

Dear Mr. Sojdehpur, among all of these tile works and artworks, which one is your favorite?

Your question is similar to asking a father, which one is your favorite child? It is natural that he will answer, all of them.

But sometimes you have a soft spot for one of them, like the tile panels depicting Hazrat Youssef (Joseph*). Even after working here for 50 or 60 years, I still gaze upon this panel daily, fully appreciating its attractiveness and its beautiful story. It also represents faith.

Now, please tell us about the religious ceremonies taking place here and of the 10th day of Moharram (Ashura).

I don't know where to start, because I would need a whole book to describe all of the different ceremonies taking place here. The different processions of chest beaters would arrive and be served lunch and dinner, together with sharbat* (sweet drink) and tea. This would be followed by the Olemas and well-known priests preaching from their mambars (pulpits).

I also really enjoyed the religious stories recited by the narrators with their curtains while they were facing the different tile panels depicting the tragedy of Karbala. We had plenty of narrators reading on curtains in Kermanshah, but during the 10 days of the month of Moharram, and especially during the Ashura day, we would invite well-known darvishes from Tehran, such as Morheb* or Darvish Mola, who would jointly do curtain readings in the Zeynabieh. What a beautiful feeling while listening to their vibrant voices. These ceremonies opened an interesting world and left long-lasting impressions on people.

ABOVE Dome with a circular geometric design also showing eight religious tile panels and calligraphic cartouches (Zeynabieh).

ABOVE Depiction of the court of Yazid the Villain showing the faithfuls being brought up as prisoners (Zeynabieh).

Dear Mr. Sojdehpur, were any repairs done to the Tekkieh Moaven ol Molk after its rebuilding?

Of course, the Tekkieh needed to be constantly repaired, and this is especially true since we had to entertain big crowds. I remember for instance that 40 or 50 years ago, part of the Tekkieh was used for schooling purposes, and unfortunately some of the students who didn't understand the importance of our tile works damaged a few of them. They were, of course, repaired later on.

Can you please tell me how many tile works are in the Tekkieh, especially since you have been working here for over 70 years?

I didn't count them personally, but informed people tell me that we have about 10,000 different tiles and tile panels here.

That is extraordinary. Can you now please tell me which are the most important subjects represented on these tile works?

Let me start with the Hosseinieh, and as I explained to you earlier, since it was located 6 meters (20 feet) below the street level, we had to build a stairway with 17 steps in order to connect the two.

You can observe tile panels here depicting Qameh Zani* and Sineh Zani* ceremonies, and then you would see a big portrait of Emam Abol Fazl (Abbas) being carried by the faithfuls as they were slowly entering the Sagga Khaneh space. I think the most important subject depicted in the Hosseinieh is that of King Soleiman* (Solomon) surrounded by his court. However, in the middle section of this building complex where the Zeynabieh is located and where the ceiling is in a form of a dome, I would say that the most elaborate and nicest tile work is the one depicting the tragedy of Karbala.

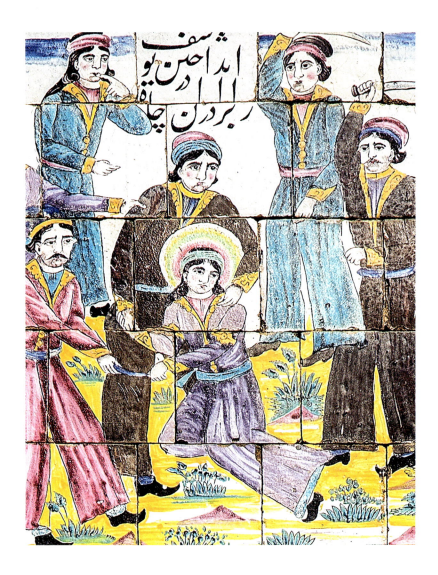

You can observe on the side walls below the dome of the Zeynabieh eight different tile works described as follows:

· The liberation of a gazelle trapped by a hunter and released by Emam Reza* (the eighth Emam of the Shia tradition).
· Preparation for the sacrifice by Hazrat Ebrahim* (Prophet Abraham) of his son Ismael (pp. 112, 113).
· Hazrat Ali fighting Mohrab (Battle of Khaybar) (pp. 114, 115).
· Moses* throwing his walking stick in front of the Pharaoh.
· Maktab Khaneh teaching to Emam Hossein and Emam Hassan (p. 91).
· Gadir Komm (p. 87).
· Mamun and Emam Reza.
· The Mi'raj* (Ascension of the Prophet Mohammad into Heaven). On the left of the same panel, Salman is being saved by Hazrat Ali from the lions (p. 102).

ABOVE Detail of top panel on opposite page (Abbassieh).

ABOVE TOP Youssef (Joseph) being thrown into the well by his brothers (Abbassieh).

ABOVE BOTTOM Youssef (Joseph) being sold as a slave to Aziz Mesri (Abbassieh).

95

واردشدن حضرة
یوسف بمجلس زنها

مهمانی کردن حضرة
یوسف برادران را

96 ABOVE TOP Ladies guests in Potiphar's wife's (Zulaikha's) house being mesmerized by Youssef's (Joseph's) handsomeness (Abbassieh).

ABOVE BOTTOM A conciliatory Youssef (Joseph) inviting his father and brothers to a feast (Abbassieh).

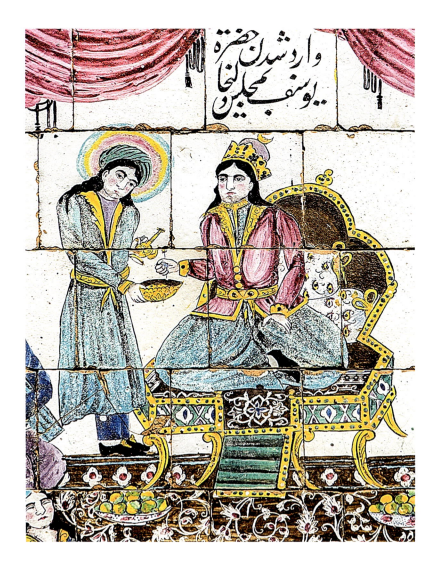

And not far from these different tile works of the Zeynabieh, you can observe the portraits of the kings of Ancient Iran. In addition to this, you can see the beautiful calligraphy done by the late Mirza Hassan Khan*, a well-known calligrapher from Kermanshah who inscribed Mohtasham Kashani's verses on the walls of the Zeynabieh.

Moaven ol Molk was also laid to rest in one of the Zeynabieh's chambers, and I will give you more details later on this subject. Now let's talk about the Abbassieh building, which also contains very interesting tile panels and which comprise the prophet Youssef (Joseph) entering the city of Canaan [and] Hazrat Ali's entourage with Emam Hossein and other important religious and political figures.

Mr. Sojdehpur, can you now give me more details about the late Moaven ol Molk's mausoleum in the Zeynabieh?

Yes, it is a good thing that you reminded me. Moaven ol Molk's death is one of the saddest and bitterest memories I still have. We are talking here about the death of an enlightened and pious man who strived his whole life to steadfastly serve his contemporaries. He died after a short illness. In fact, he died in 1947 and had instructed

ABOVE Entrance door with tile details (Hosseinieh).

in his will to be buried somewhere in this Tekkieh. On the day of his death, large crowds showed up comprised of the heads of the different tribes, of chest beaters, and of important religious figures as well as of prominent citizens of Kermanshah.

The chest beaters processions arrived one after another and reminisced about Moaven ol Molk in their incantations. He was buried in one of the Zeynabieh's rooms, and I will commend here the very good job done by both the mirror maker and the stone maker who carved the elegant calligraphy on his tombstone. It seems unbelievable, but the majority of visitors coming here go to his tomb and pray for his soul while remembering the fond memories they had of him.

ABOVE Detail showing a sun and a lion holding a sword (Hosseinieh).

99

I think that after the death of Moaven ol Molk, your only pleasure was for you to visit his tomb and pray for his soul.

Let me confess to you that for a servant like me who has spent almost all of his life with Moaven ol Molk, it was really difficult to accept he had died. Whenever I visit his tomb, I never think I am dealing with a deceased person. I visit his tomb daily after my morning and afternoon prayers, and my first sentence is always to say hello to him, and then ask him how he is doing. I also talk to him about my own personal problems. This is what happens while I am awake. He sometimes appears in my dreams, and we discuss the Tekkieh, and he is always worried about the condition of the tiles and wants to make sure that we keep the Hosseinieh, Zeynabieh, and Abbassieh clean at all times. I always follow his instructions.

What was the most memorable dream you had of Moaven ol Molk?

They were all memorable, but there is one dream in particular that holds my attention. I dreamt that Moaven ol Molk was sitting in Hazrat Soleiman's (Solomon) court, just as depicted on the tile panel here. Moaven ol Molk was seated next to Hazrat Soleiman (Solomon), wearing a very opulent dress and fine jewelry. I approached him and asked him, what are you doing here?

His answer was, "My dear Ebrahim, I possess in my own right Hazrat Soleiman's treasures, and if Hazrat Soleiman possesses all of the finest objects and jewels of the world, I was allowed to join this court because I built this Tekkieh. In the end, what counts is not the material possessions and jewels you have accumulated during your lifetime but the good deeds and charitable work you did. You also have to leave a meaningful legacy. Ebrahim, since I built this Tekkieh, I am a man of unequalled wealth; please watch this treasure with great care as long as you are alive." I answered him, Mr. Moaven ol Molk, don't worry, I will take good care of it, you can fully count on me. I immediately woke up after I had said this last sentence.

ABOVE The faithfuls entering the sacred city of Medina. Signed by Hassan, a tile maker from Tehran (Zeynabieh).

ABOVE On the left of this panel, the Mi'raj (Ascension of the Prophet Mohammad into Heaven).
On the right of the same panel, Salman is being saved by Hazrat Ali from the lions (Zeynabieh).

These discussions were recorded on seven cassette tapes. Unfortunately, some of the tapes were damaged with the passage of time, and for this reason I have reported some of the material to the best of my recollection. I was extremely careful in my notes and tried to come as close as possible to the original when reporting the discourse of Mr. Ebrahim Sojdehpur.

It is important to note that Mr. Sojdehpur didn't have an academic background, and his level of education was at the level of Maktab Khaneh (religious school), which would be equivalent to a middle-school education. We nevertheless have to recognize the importance of his recollections and give credence to his observations. The old guardian is the only sincere narrator of the events surrounding the Tekkieh and who was still alive at that time. He spent 70 years of his life there. His discourse gave a lot of credence to the oral history of these buildings.

ABOVE Prophet Youssef (Joseph) entering the city of Canaan (Abbassieh).

ABOVE Detail of tile panel on the left (Abbassieh).

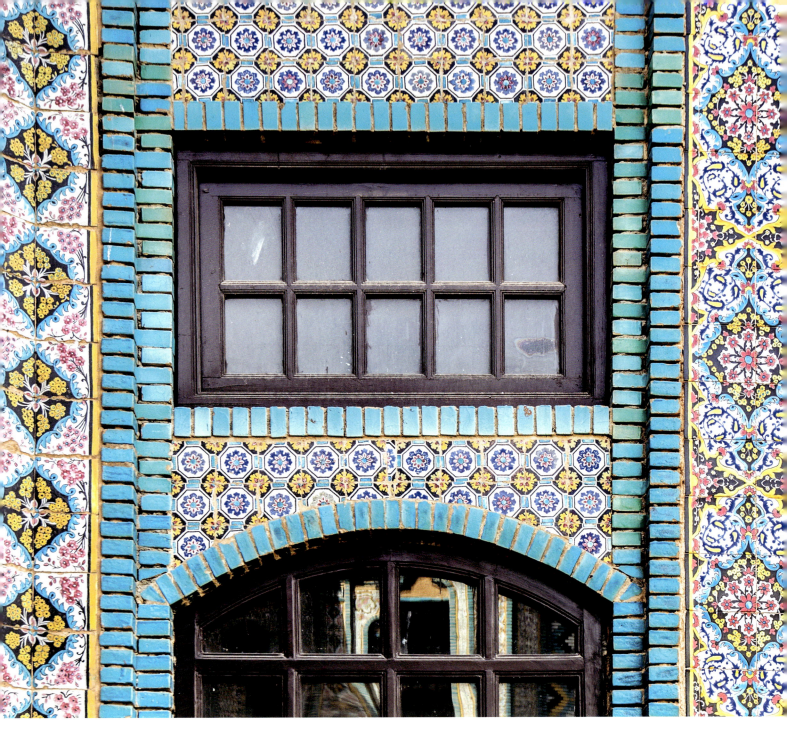

106 ABOVE Geometric tiles with floral motives (Abbassieh).

ABOVE Floral geometric tile panel design.

107

PREVIOUS PAGES Entrance doors (Abbassieh).

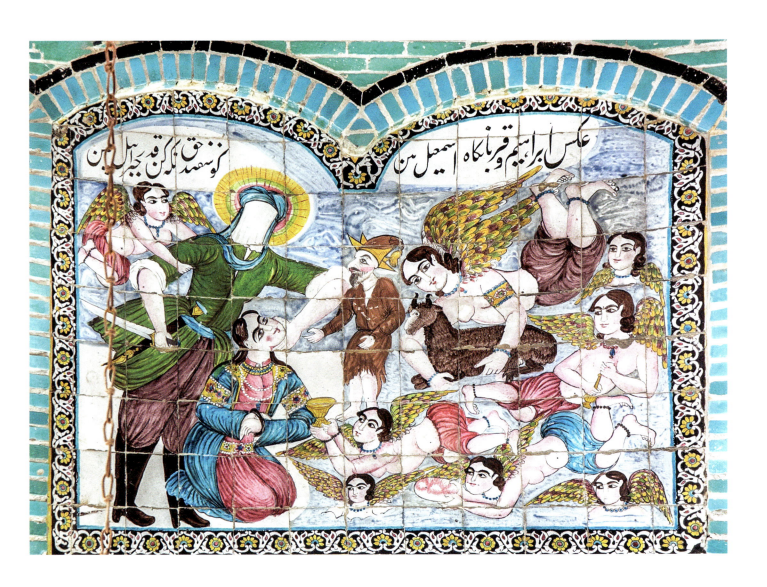

ABOVE Hazrat Ebrahim (Abraham) preparing to sacrifice his son Ismael on God's order (Zeynabieh).

عکس ابراهیم و قربانگاه اسمعیل من

114 ABOVE Hazrat Ali fighting Morhab the Villain during the Battle of Khaybar (Zeynabieh).

ABOVE Detail of the tile panel on the left (Zeynabieh). 115

Interview with Me'mor Qasem Ahmadi by Hadi Seif

Me'mor Qasem Ahmadi carried out major repair work on the Tekkieh Moaven during the 1960s.

I was savoring a cup of tea on April 27, 1994, in the garden of the Tekkieh Moaven after having extensively interviewed Morshed Ebrahim Sojdehpur when suddenly a middle-aged man entered the premises and went straight to Morshed Sojdehpur.

I had known Morshed Sojdehpur for some time by now and had never seen him as happy as when encountering this new visitor. He hugged this newcomer warmly and kept repeating, "Welcome Mr. Me'mor, you are arriving at the right time." Ebrahim introduced me as a researcher and said, "Ostod Qasem Ahmadi is a well-known builder in Kermanshah," as Me'mor Ahmadi slightly bent his head toward the ground as a sign of humility. Ebrahim offered him a cup of tea and then said, "Your work was almost divine; if you hadn't rescued and restored this Tekkieh, it wouldn't be standing here today. You initially were just talking about touching it up and doing small repairs, but in reality you rebuilt it almost completely."

Considering the wonderful work done by Me'mor Ahmadi, I decided at this juncture to have a short conversation with him.

ABOVE Me'mor Qasem Ahmadi.

ME'MOR AHMADI I was born in 1943 in Kermanshah and had developed a taste for construction early on and started to work as an apprentice when I was 15 years old for a builder named Ali Mirza Larti. Later on, I changed jobs and started working for another builder by the name of Hadi Azadi. I am eternally indebted to both of them since they taught me how to restore traditional buildings. Thanks to the experience I accumulated over the years, I was then hired by a governmental organization called the Miras Farhangi* in 1974.

Yes, I restored and repaired several historical structures in Kermanshah and here are some examples:
- An old bridge dating back to the Safavid era*
- The Beglarbegi Tekkieh dating back to the Qajar era
- The Tagh Bastan bas reliefs dating back to Ancient Iran and to the Sassanid era*
- The City Hall building also dating back to the Qajar era

In the middle of Me'mor Ahmadi's discourse, Ebrahim Sojdehpur interjected:

EBRAHIM SOJDEHPUR We should also remember all of the other builders and tile makers who were involved in the construction and decoration of this Tekkieh.

ME'MOR AHMADI You are absolutely right, Morshed Ebrahim, since you are a living witness of the history of this Tekkieh.

EBRAHIM SOJDEHPUR I would like to bring to your attention the people like the late Me'mor Asghar (Me'mor Bashi), the late Ostad Mohammad, also known as Siah, the late Ostad Hashem Ketabi, and the late Haj Mirza Hassan, a tile maker from Tehran.

All of the gentlemen I mentioned here were the most prominent people who worked here. Among the names I mentioned, Ostad Mohammad had outstanding skills. I also witnessed how Me'mor Ahmadi worked here tirelessly; I have known him since he was a very young man.

SEIF *Ostad Ahmadi, can you please summarize the work you did here?*
OSTAD AHMADI I don't want to brag, but if I had not worked tirelessly on this Tekkieh, it would have turned into a mountain of rubble eventually.

ABOVE The Tekkieh Moaven under reconstruction in the 1960s (Zeynabieh).

Here are some examples of the work I did:

- I replaced the flooring tiles with similar ones. Regarding the repairs of the walls, I used a gholeb bandi (mold) to replicate its details and also repaired the pay bandi (foundations).
- I ordered new tiles similar to the old dilapidated ones, replaced the wooden frames of the buildings with new steel frames and also rebuilt the outside concrete water feature of the Hosseinieh with a new one made out of stone.
- I also dug a brand new sewage canal in the Zeynabieh that was 30 meters long, 1.5 meters deep and 1 meter wide. This allowed for the sewage to be channeled out.
- In addition to this, I drained all standing water and insulated the flooring by pouring concrete and asphalt over it.

I took all of these steps in order to keep all moisture at bay and the place dry.

SEIF *Ostad Ahmadi, how do you compare the importance of this Tekkieh with some of the other Tekkiehs?*

OSTAD AHMADI The importance of the Tekkieh Moaven is due to the tile works shown here, but it also has its own character. Regarding the tile works, I would like to remind you that the late Hassan Moaven ol Molk ordered initially that the interior walls should be covered with plaster works, mirror works, and paintings. Some of the original artisans who were from Kermanshah, such as Ostad Hassan Naghash and Seyed Abol Ghassem Mani, a tile designer, were invited to decorate the building. Later on, however, Moaven ol Molk invited Haj Hassan, a tile maker from Tehran, and Minachi to join them. Haj Hassan came here with his family.

Upon his arrival, he built a kiln for firing his tiles. All other forms of decoration, such as the paintings, plaster works, and mirror works, were then gradually replaced with long-lasting and beautiful tile works. In a relatively short time, Haj Hassan kept his end of the bargain and decorated the Tekkieh with elegant tile works.

SEIF *Since I met Me'mor Ahmadi by coincidence and I didn't have a tape recorder with me, I wrote down the notes of this meeting.*

Me'mor Ahmadi also published a book dealing with his many restorations, whose title translates as Restoration Carried out on Old Buildings in the Province of Kermanshah. *This book was published in 1995, but he unfortunately passed away before its publication.*

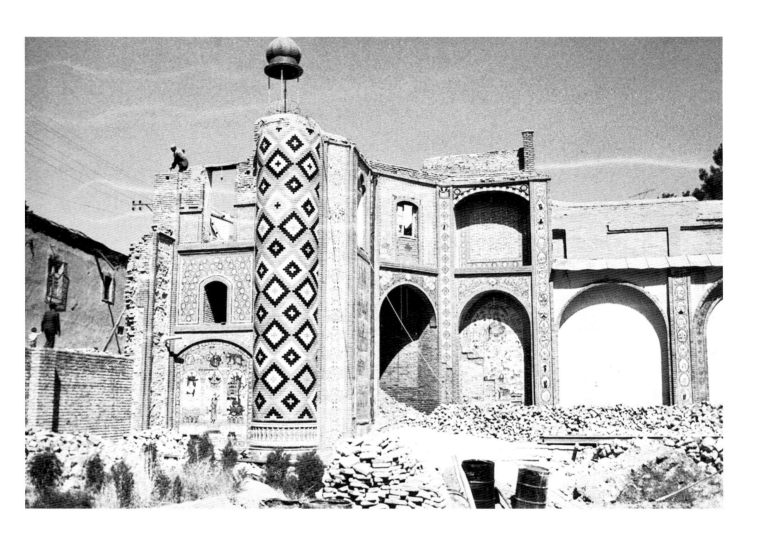

ABOVE The Tekkieh Moaven under reconstruction in the 1960s (Zeynabieh).

ABOVE Recent photograph (2019) of the same view of the Tekkieh Moaven (Zeynabieh).

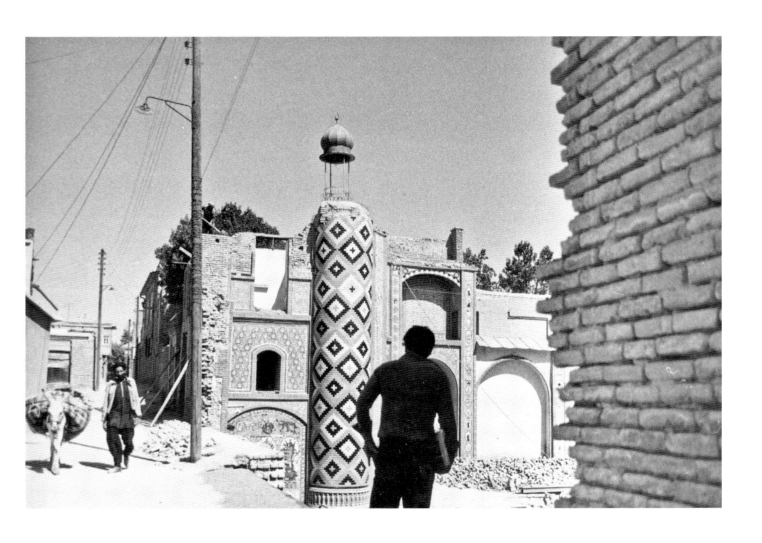

ABOVE The Tekkieh Moaven during the 1960s after many decades of deterioration.
View from the street shown in the picture on the right (Zeynabieh).

ABOVE Restored elements shown in the picture on the left. The wall on the left side of this picture
was completely restored (Zeynabieh).

ABOVE Building before its reconstruction during the 1960s (Hosseinieh).

ABOVE During the reconstruction and restoration in the 1960s, part of the building visible on the
picture on the left was demolished (Hosseinieh).

Glossary

Abbas ('Abbās bin 'Alī bin Abū Ṭāleb, Abol Fazl, Qamar Bani Hashem) → A half-brother of Emam Ḥosayn who fought bravely at the Battle of Karbalā. 'Abbās was killed, according to most traditions, on the day of 'Āšūrā (10 Moḥarram 61/ 10 October 680) while trying to bring back water from the Euphrates river to quench the unbearable thirst of the besieged Ahl-e Bayt (holy family).
SOURCE: ENCYCLOPEDIA IRANICA.

Abbassieh → One of the three buildings that are part of the Moaven ol Molk Tekkieh complex. This building was dedicated to Hazrat Abbas, the half-brother of Emam Hossein, who was killed at the Battle of Karbala.

Abshouran → Quarter in the city of Kermanshah.

Alam → One of the most important and symbolic objects used during mourning rituals is the Alam. It is the ensign of Husayn ibn Ali in the Battle of Karbala and a sign of truth and bravery. During the Battle of Karbala, the original flag bearer of Husayn ibn Ali's Kafala (caravan) was Abbas, Husayn ibn Ali's half-brother. Abbas lost his life in battle when he went to retrieve water from the Euphrates river for the caravan's young children, who were thirsty for three days. The story goes that when he started to ride back to the camp with the water, he was unexpectedly attacked. While in battle, the children of the camp were anxiously watching the Alam (flag) dip up and down from afar. Abbas lost both of his arms in battle, yet he continued to clench the water skin (mushk) with his teeth, determined to bring the water back to the children. The leader of the opposition saw Abbas gaining ground and ordered for more army men to attack the flag bearer, stating, "If water is brought back to their tent, there is no stopping them." Archers then started bombarding Abbas with arrows, which pierced the water skin, bringing Abbas down from his horse and the Alam to the ground. Alams are a reminder of Abbas's martyrdom and act as a symbol of affection and salutation toward the followers of Husayn ibn Ali who lost their lives in Karbala.

Alams all vary in size but usually consist of a wooden pole base with a metal standard fixed at the top of the pole. The pole is then dressed with cloth and a banner with the names of the Prophet Mohammad's family members. Alams with Abbas's name usually include an ornament that resembles the water skin that he intended to fill for the children. The length of an Alam can be about 4.5 meters (15 feet). An Alam consists of flexible steel plates placed on the upper part and is decorated by plumes and fine embroidered silks and brocades.

Alī bin Abī Ṭāleb (b. ca. 600, d. 40/661) → Cousin and son-in-law of the Prophet Moḥammad, first Shi'ite Emam, father of the Emams Ḥasan and Ḥosayn by Fāṭema, and fourth caliph (35–40/ 656–661). According to the Shi'ites, the Prophet unequivocally nominated 'Alī as his successor at Ḡadīr Ḵomm while returning from his "farewell pilgrimage" to Mecca. SOURCE: ENCYCLOPEDIA IRANICA.

Andaruni (Andarūn, or Andarūnī [inside]) → The private quarters of well-to-do houses in contrast to bīrūnī. the public rooms usually reserved for men. Until quite recently, Persian houses of the affluent, landowners, and wealthy merchants were run as two separate spheres of andarūnī and bīrūnī. The andarūn was the preserve of female members of the family: mother, wife or wives, nurses, nannies, other female servants, and children of both sexes until the age of puberty, at which time the male children were separated from the female and sent to the bīrūnī.

The andarūn consisted of a complex of rooms which served for entertainment, sleeping, and carrying out daily household chores. It was here that the kitchen, pantry, and storage rooms were located. In contrast to the austerity characteristic of the bīrūnī, the larger rooms were usually richly furnished with carpets, silk-covered cushions, and interior decoration. On occasions such as births, weddings, circumcisions, funerals, and return from pilgrimages, female visitors were entertained in the andarūn, where, upon entering, they doffed their veils (rūbandas) and sturdy shoes for silk and brocade dresses and soft, comfortable slippers. SOURCE: ENCYCLOPEDIA IRANICA.

Ashura (Asura, 'āšūrā') → 10th day (of the month) of Moḥarram, the first month of the Islamic calendar; for Sunnis it is a day on which fasting is recommended, and for Shi'ites a day of mourning for the martyrdom of Emam Ḥosayn. See also 'Āšūrā' in Shi'ite.

Assar va Ajam → The works of Ajam, book written by Forsat ol Dowleh Shirazi dealing with drawings of historical sites of Iran, especially of the Shiraz province.

'Āšūrā' in Shi'ite → piety. After the death of Mo'āwīa in the spring of 60/680, his son Yazīd succeeded him as caliph. Yazīd's succession by hereditary appointment rather than election or popular acclaim met with strong opposition in many quarters of a community already torn by conflict and dissension. Among the many dissenting groups was the party (Šī'a) of 'Alī bin Abī Ṭāleb*, led by his son, Emam Ḥosayn. Ḥosayn's supporters in Kufa urged him to lead them in revolt against Yazīd's rule; after some hesitation, he answered their persistent entreaties, not solely due to political motives but also because of an idealistic view of Islam that he sought to defend at all cost. His martyrdom has therefore been regarded by Muslims, Sunnis, and Shi'ites as the model for self-sacrifice in the way of God, a revolt against wrong-doing and oppression. This fact has not been fully appreciated by most Western histo-

rians, yet it is crucial for a true understanding of the significance of ʿĀšūrāʾ for the Muslim community in general, and especially its Shiʿite members. Ḥosayn left for Kūfa with his family and about 70 men. On the second of Moḥarram, 61/680, he encamped on the plain of Karbalāʾ, where he faced an army of about 4,000 men sent to intercept him by the governor of Kūfa, ʿObaydallāh bin Zīād. After a week of fruitless negotiations, the head of the army, ʿOmar bin Saʿd, put the choice to Ḥosayn and his followers of either surrendering to the authority of Ebn Zīād or fighting. The battle that ensued lasted from early morning to mid-afternoon. Ḥosayn and his followers, including the able male members of his family, were killed; his women and children were taken captive, first to Kūfa then to Damascus. Yazīd, who had appointed Ebn Zīād governor of Kūfa specifically to deal with the problem of Ḥosayn, was moved by the pitiful sight of the captives and finally, at their own request, sent them back to Medina.

Commemorative services (majāles al-taʿzīa) first held in the houses of the Emams and their followers, originally consisted of recounting the tragedy, reflecting on its meaning, and reciting elegies (marāṯī) in memory of the martyred Emam. From the beginning, these majāles were not limited to the ʿĀšūrāʾ days but were and still are held at any time of the year. Soon the shrines of the Emams in Iraq and Iran became important centers of pilgrimage (zīāra), where the pious held their lamentations. SOURCE ENCYCLOPEDIA IRANICA.

Bas relief → A type of art in which shapes are cut from the surrounding stone so that they stand slightly against a flat surface. SOURCE: CAMBRIDGE DICTIONARY.

Bazaar (bazar, bāzār) → The Iranian bāzār is a unified, self-contained complex of shops, passageways, and caravanserais, interspersed with squares (meydān), religious buildings, bathhouses (ḥammām), and other public institutions. Such a traditional commercial center is usually roofed with vaulted ceilings made from fired brick, although the outer branches may be open or have only makeshift coverings of wood or reeds. Light and air circulation come from small openings in the brick vaults, and the height of the ceilings keeps the halls cool and comfortable during the long hot season, even though the bāzār can be rather chilly in the winter. The shops (dok[k]ān), small single-storied stalls 3 or 4 meters in width, lined each side of the lanes and contain retailers and craftsmen, who often are grouped in separate branches (rāsta) by occupational types. Typically no residences are located within the bāzār, and so the main complex can be closed at night or on holidays (or during political protests by the bāzārīs). SOURCE: ENCYCLOPEDIA IRANICA.

Biruni (bīrūnī) → The public or male quarters of wealthy households, used for conducting business, male religious ceremonies, and parties for men. SOURCE: ENCYCLOPEDIA IRANICA.

Chest beating (Persian: سینه زنی; Sineh Zani) → Ritual performed by Shia Muslims while mourning Emam Hossein during the month of Moharram. Mourners gather into the middle of the courtyard, bare their upper torsos in the form of a procession, and begin randomly beating their chests.

Coffee House painting (style) → An Iranian narrative painting style with epic, religious, and festive themes from the early 1900s based on Iranian folklore art traditions. It is a special genre of Persian folk art, resembling Persian miniature painting.
SOURCE: FINANCIAL TRIBUNE, SEPTEMBER 7, 2018.
The founders of the Coffee House painting style are reputed to be Ali Reza Gholar Aghassi, his son Hossein Gholar Aghassi, and his apprentice Mohammad Modaber.

Constitutional Revolution → The establishment of a constitutional regime (monarchy) in Persia was the chief objective of the Revolution of 1323–1329/ 1905–1911. Like any other major revolution, the Constitutional Revolution in Persia encompassed a broad spectrum of ideas and objectives, reflecting diverse intellectual trends, social backgrounds, and political demands. At the time, even the text of the Constitution itself did not have universal support. Yet, in spite of ideological ambiguities, the Revolution remains an epoch-making episode in the modern history of Persia because of its political achievements and its enduring social and cultural consequences. As a modern revolution, it was aimed at dislodging the old order by means of popular action and by advocacy of the tenets of liberalism, secularism, and nationalism. For the first time in the course of modern Persian history, the revolutionaries sought to replace arbitrary power with law, representative government, and social justice and to resist the encroachment of imperial powers with conscious nationalism, popular activism, and economic independence. Constitutionalists also tried to curb the power of the conservative religious establishment through modern education and judicial reforms. By centralizing the state, they sought to reduce the power of the tribal and urban notables. The greater sense of nationhood that emerged out of the Revolution has remained essential to the modern Persian identity.

That the Constitutional Revolution was the first of its kind in the Islamic world—earlier than the revolution of the Young Turks in 1908—can be partly explained by the situation in Persia in the latter half of the 19th century.

Early evolution of constitutional concepts:

The first demands of the Constitution itself were endorsed by Moẓaffar-al-Dîn Shah before his death on 23 Ḏu'l-qaʿda 1324 (January 9, 1907), with the understanding that neither the deliberations nor the legislation of the Majles (Parliament) would compromise the prerogatives of the shah. It was only after the accession of Moḥammad-ʿAlî on 28 Ḏu'l-ḥejja 1324 (February 11, 1907) that the shah was requested for the first time by the Majles to acknowledge that Persia was a constitutional (*maðrûṭa*) state. After much semantic bargaining, he modified the proposed text of the *farmân* by

defining the term *maðrûṭa* as "constitution" (*konsṭeṭûsîon*), presumably as a bar to a broader, possibly even republican, interpretation of *maðrûṭa*. Nevertheless, only a few low- and middle-ranking clerics and a handful of guildsmen, merchants, and pro-reform notables among the deputies were sincerely dedicated to constitutionalism. Most deputies saw the Majles as an advisory body to oversee judicial, fiscal, and administrative reforms. Class divisions did not determine their ideological orientations. SOURCE: ENCYCLOPEDIA IRANICA.

In these turbulent times, Mohammad Ali Shah Qajar invited the Russian Cossack troops under the command of Vladimir Liakhov to quell the Revolution. These troops even bombarded the Parliament (Majles) in 1908.

Constitutionalists → Also known as Freedom Seekers or Freedom Fighters. They were in favor of having the country adopt a new constitutional monarchy.

Dar ol Sanaye Nasseri → Craftsmen's quarter in Tehran.

Darvish (dervish, darvis) → In the Islamic period the term darvīš, or dervish, has been variously applied to claimants to the virtue of spiritual poverty—that is, non-attachment, often in conjunction with deliberately chosen or passively accepted material poverty; adherents or practitioners of Sufism, especially its undisciplined or antinomian forms; and mendicants with pretensions to sanctity. SOURCE: ENCYCLOPEDIA IRANICA.

Ebrahim, Hazrat (Ebrahim-Esmail, Abraham, Abram, Ebrāhīm) → The name of the first patriarch of the Hebrew people.

In Judaism: In its original form, the name Abram occurs in the Bible (Gen. 11:26, 17:5; Nehemiah 9:7; and 1 Chron. 1:26), as does the form Abraham. No one else bears his name, for which two meanings have been suggested: "the exalted father" and "the father of the exalted."

In Islam and in tradition: Ebrāhīm was known to (Prophet) Moḥammad as one of the earliest prophets to profess monotheistic belief. He is venerated in the Quran (3:110, 106) as the father of the Arabs and the first who professed Islam. SOURCE: ENCYCLOPEDIA IRANICA.

A large number of stories of the prophets in the Quran are devoted to the life, deeds, and beliefs of Ebrāhīm; he is mentioned in 25 different suras, with information mostly based on Talmudic and Midrashic legends. According to the Quran, Ebrāhīm recognized Allāh as the creator of the world; Ebrāhīm is also mentioned as the idol-smasher who was miraculously saved from the furnace, and the one who accepted Allāh's command to sacrifice his son. SOURCE: ENCYCLOPEDIA IRANICA.

Emams 12 → The Twelve Emams are the spiritual and political successors to the Islamic (Prophet) Mohammad in the Twelver or Athnāʿashariyyah branch of Shia Islam, including that of the Alawite and the Alevi sects.

According to the theology of Twelvers, the Twelve Emams are exemplary human individuals

who not only rule over the community with justice but also are able to keep and interpret sharia and the esoteric meaning of the Quran. (Prophet) Mohammad and Emams' words and deeds are a guide and model for the community to follow; as a result, they must be free from error and sin (known as ismah, or infallibility) and must be chosen by divine decree, through the Prophet.

Esfahan native (Esfahani) → People from the city of Esfahan, who are well known for their artistic skills, good taste, and humor.

Farahani, Mohammad → Apprentice of the tile maker and painter Hossein Gholar Aghassi and well-known designer of Darvish curtains.

Feiz Abad → Part of the city of Kermanshah.

Flagellation → Acts of flagellation are a symbolic reenacting of the bloodshedding of Husayn ibn Ali. The previous record of this dramatic act reaches back to the 17th-century practice in the Caucasus and in Azerbaijan and was observed in the 19th century by the Shia Twelvers in central and southern cities of Iran and the Arab world. There were various types of flagellation, including the striking of chests with the palms, striking of backs with chains, and cutting foreheads with knives or swords.

Forsat ol Dowleh Shirazi (Forsat Al Dawla) → A well-known scholar from the city of Shiraz.

He wrote the book *Assar va Ajam* (The Works of Ajam), his best known work, a collection of more than 50 drawings of various historical sites of Persia, especially (the province) of Fars (Bombay, ca. 1322/1905). SOURCE: ENCYCLOPEDIA IRANICA.

Friday → Day of congregation and worship for Muslims.

Gadir Komm → Lit.: "pool of Ḵomm," the name of a pool near a small oasis along the caravan route between the cities of Mecca and Medina, near an area currently known as Joḥfa. According to Shiʻites, this is the site at which the Prophet Moḥammad announced the authority of ʻAlī bin Abī Ṭāleb over the Muslim community. SOURCE: ENCYCLOPAEDIA IRANICA ONLINE.

Gholar Aghassi, Ali Reza → Father of Hossein Qullar Agasi. He was also the co-founder of the Qaveh Khaneh (Coffee House) style of painting.

Gholar Aghassi, Hossein → The son of Ali Reza Qullar Agasi who did several tile works at the Tekkieh Moaven. He, together with his father and Mohammad Modaber, was a founder of the Qaveh Khaneh (Coffee House) style of painting.

Haft rang (seven-colored tiles) → Series of dyes used for coloring tiles.

Haj Bagher Jahanmiri → Shirazi tile maker from the early 20th century.

Haj Hassan Ostad Kashipaz Tehrani → A tile maker from Tehran and Master tile worker who worked at the Tekkieh Moaven.

Hamedan → City in Hamedan province, 120 miles east from Kermanshah.

Hamedani, Mirza Jalal Kashipaz → A tile maker from Hamedan who worked with Mirza Abdol Razzogh, a famous tile maker from Shiraz. They both did some tile works for the Tekkieh Moaven.

Hammam → Public bathhouse.

Hossein, Emam (Hosayn, Husayn, Hussein) → A grandson of (Prophet) Mohammad and brother of Hasan ibn Ali. Husayn opposed the validity of Caliph Yazid I. As a result, he and his family were later killed in the Battle of Karbala by Yazid's forces. After this incident, the commemoration of Husayn ibn Ali became central to Shia identity.

Hosseinieh (ḥosayniya, hussainiya, Persian: حسينيه hoseyniye) → A congregation hall for Twelver Shia Muslim commemoration ceremonies, especially those associated with the Mourning of the Month of Moharram. The name comes from Husayn (Hussein) ibn Ali, the third of the Twelve Emams and the grandson of the Islamic (Prophet) Mohammad. There are also other ceremonies which are held during the year in Hussainiyas, including religious commemorations unrelated to Ashura.

Judgment Day → Muslims believe that at the end of time, all human beings will have to face God and account for their deeds, good and bad. God will judge them accordingly, assigning reward or punishment. The time of the Day of Judgment is not specified in the Quran but is understood to be near. Its depiction is similar to biblical accounts, with earthquakes, moving mountains, the sky splitting open, heaven being rolled back, the sun ceasing to shine, stars being scattered and falling upon the earth, oceans boiling over, graves opening, and the earth bringing forth hidden sins as well as lost stories and the dead themselves and people vainly trying to flee divine wrath. Everyone will bow before God. Traditional Islamic thought portrays the Day of Judgment as preceded by cosmic battle between Satan's forces, represented by the false messaiah al-Dajial and Gog and Magog, and God's forces, led by the Mahdi and Jesus.

SOURCE: OXFORD ISLAMIC STUDIES ONLINE.

Karbala (Karbalā') → A city in Iraq, situated about 90 kilometers southwest of Baghdad. It is one of the four Shiʻite shrine cities (along with Najaf, Kāẓemayn, and Sāmarrā') in Iraq known in Shiʻite Islam as ʻatabāt-e ʻaliāt or ʻatabāt-e moqaddasa (lit.: "sublime or sacred thresholds"). The third Emam of the Shiʻites, Ḥosayn bin ʻAlī, and his half-brother ʻAbbās are buried there. The plain of Karbala was the site of the battle on 10 Moḥarram 61 (October 10, 680) between Emam Ḥosayn and the Omayyad army. Ḥosayn, with a party of 72 armed men and some women and children, was on

132

his way from Medina to Kufa, whose inhabitants had invited him to lead a rebellion against the Omayyads. Before reaching Kufa, Ḥosayn was intercepted by an Omayyad force, and, following negotiations, he agreed to return to Medina. On 2 Moḥarram his party reached the plain of Karbala, where they were surrounded by another 4,000-strong Omayyad force sent by 'Obayd-Allāh bin Ziād, the governor of Kufa, and led by 'Omar bin Sa'd bin Abi Waqqāṣ, who had been instructed not to allow Ḥosayn to proceed unless he signed a pledge of allegiance to the caliph Yazid bin Mo'āwia. Ḥosayn sought to return to Medina without making the pledge, but 'Omar bin Sa'd did not relent. On 10 Moḥarram, known in Shi'ism as 'Āšurā', the uneven battle took place. Gradually all of Ḥosayn's able male companions were slaughtered, with Ḥosayn, according to Shi'ite tradition, the last one to be killed.

The Omayyad army looted Ḥosayn's camp, decapitated the bodies of all his companions, and took all the women and children prisoners, among them Ḥosayn's surviving son 'Alī, who became the fourth Shi'ite Emam, Zayn-al-'Abedin. The Karbala tragedy became the constitutive event of Shi'ism as a religion and the symbol of the victory of the oppressive majority over the righteous few, symbolizing whatever went wrong in Islamic history.

SOURCE: ENCYCLOPEDIA IRANICA.

Khaibar (Khaybar) → The Battle of Khaybar (Arabic: غَزْوَة خَيْبَر) was fought in the year 628 between Muslims and the Jews living in the oasis of Khaybar, located 150 kilometers (93 miles) from Medina in the northwestern part of the Arabian peninsula, in modern-day Saudi Arabia. Jewish tribes reportedly arrived in Hijaz in the wake of the Jewish-Roman wars and introduced agriculture, putting them in a culturally, economically, and politically dominant position. According to Muslim sources, the Muslim soldiers attacked the native Jews, who had barricaded themselves in forts. Muslim sources accused Jews living in Khaybar of a plan to unite with other Jews from Banu Wadi Qurra, Taima', Fadak and Ghatafan Arab tribes to attack Medina.

Scottish historian William Montgomery Watt notes the presence in Khaybar of the Banu Nadir, who were working with neighboring Arab tribes to protect themselves from the Islamic community in Medina who had earlier sent the Jewish tribes into exile for violating the terms of the Charter of Medina and for conspiring to kill (Prophet) Mohammad. Italian orientalist Laura Veccia Vaglieri claims other motives might have included the prestige the engagement would confer upon (Prophet) Mohammad among his followers, as well as the booty which could be used to supplement future campaigns.

The Jews of Khaybar finally surrendered after seeing no way out and were allowed to live in the oasis on the condition that they would give one half of their produce to the Muslims. Jews continued to live in the oasis for several more years until they were expelled by the caliph Umar. The imposition of tribute upon the conquered Jews served as a precedent for provisions in the Islamic law

requiring the exaction of tribute known as *jizya* from Dhimmi subjects in areas under Muslim rule, and confiscation of land belonging to non-Muslims into the collective property of the Muslim community.

Maktab Khaneh → Before the establishment of a modern educational system in Persia in the early 20th century, children received their early and intermediate education in the maktab (or maktab-ḵāna, lit.: "place of writing") under the tutelage of an āḵūnd, mulla (clerical teacher), or mo'allem (teacher), who worked alone or occasionally with one or two assistants. SOURCE: ENCYCLOPEDIA IRANICA.

Mambar (Minbar) → Pulpit from where the mullah preached to the congregation.

Mani → A thinker, a thoughtful person.

Me'mor Bashi, Ostad → Builder hired by Moaven ol Molk to reconstruct the Tekkieh Moaven after its destruction. He is also known as Me'mor Asghar.

Minachi, Ostad → One of the tile makers that worked at Tekkieh Moaven on its reconstruction with Haj Hassan, a tile maker from Tehran.

Mi'raj (Mi'rāj) → In Islam, the ascension of the Prophet Mohammad into heaven. In this tradition, (Prophet) Mohammad is prepared for his meeting with God by the archangels Jibrīl (Gabriel) and Mīkāl (Michael) one evening while he is asleep in the Ka'bah, the sacred shrine of Mecca. They open up his body and purify his heart by removing all traces of error, doubt, idolatry, and paganism and by filling it with wisdom and belief. SOURCE: ENCYCLOPEDIA BRITANNICA.

Miras Farhangi → Governmental organization in charge of preserving the cultural heritage of Iran.

Mirror making (Aineh-Kari) → The art used extensively to decorate the interior of buildings with mirrors or mirror work. Essentially, mirror work is the art of making ordered, symmetrical, and geometric designs using large and small pieces of mirror. SOURCE: IRAN GAZETTE ONLINE.

Mirza Abdol Razzogh → Famous Shirazi tile maker, who also contributed with some of his works to the Tekkieh Moaven.

Mirza Hassan Khan → A well-known calligrapher from Kermanshah who inscribed the verses of the 16th-century poet Mohtasham Kashani on the Zeynabieh building.

Modaber, Mohammad → He was the apprentice of Ali Reza Gholar Aghassi, a good friend of Hossein Gholar Aghassi, and one of the founders of the Qaveh Khaneh (Coffee House) style of painting.

Moharram (Muharram, Month of Muharram) → Also known as the Remembrance of Muharram or

Muharram Observances, a set of rituals associated with mainly Shia Muslims; however, some Muslims from other sects, as well as some non-Muslims, also take part in the remembrance. The commemoration falls in Moharram, the first month of the Islamic calendar. Many of the events associated with the ritual take place in congregation halls known as Hussainia (Hosseinieh). The event marks the anniversary of the Battle of Karbala, when Emam Hossein ibn Ali, a grandson of (Prophet) Mohammad, was killed by the forces of the second Umayyad caliph.

Mollahs → The name commonly given to local Islamic clerics or mosque leaders.

Morheb and Darvish Mola → Dervishes from Tehran who jointly did curtain readings in the Zeynabieh, especially during the month of Moharram.

Morshed (Murshid, Arabic: مرشد) → Arabic for "guide" or "teacher," derived from the root r-sh-d, with the basic meaning of having integrity, being sensible, mature.

Moussa, Hazrat (Moses) → (Flourished 14th–13th century BC), prophet of Judaism. According to the Book of Exodus, he was born in Egypt to Hebrew parents, who set him afloat on the Nile in a reed basket to save him from an edict calling for the death of all newborn Hebrew males. Found by the Pharaoh's* daughter, he was reared in the Egyptian court. After killing a brutal Egyptian taskmaster,

he fled to Midian, where Yahweh (God) revealed himself in a burning bush and called Moses to deliver the Israelites from Egypt. SOURCE: ENCYCLOPEDIA BRITANNICA.

Mozaffer al Din Shah Qajar → Son of Nasser al Din Shah, who reigned from 1896 to 1907 and is credited with the passage of the Constitution by the Majles (Parliament) in 1906. He died in 1907.

Nasir al Din Shah Qajar → Nāṣer al-Dīn Shāh, also spelled Nāṣir al-Dīn Shāh, born July 17, 1831, near Tabrīz, Iran—died May 1, 1896, Tehrān, Qājār shah of Iran (1848–1896) who began his reign as a reformer but became increasingly conservative, failing to understand the accelerating need for change or for a response to the pressures brought by contact with the Western nations. SOURCE: ENCYCLOPEDIA BRITANNICA.

Olama (olema, ulamā', also spelled ulema) → The learned of Islam, those who possess the quality of 'ilm, "learning," in its widest sense. From the 'ulamā', who are versed theoretically and practically in the Muslim sciences, come the religious teachers of the Islamic community—theologians, canon lawyers (muftis), judges (qadis), professors, and high state religious officials like the shaykh al-Islām. SOURCE: ENCYCLOPEDIA BRITANNICA.

Persepolis → Founded by Darius I in 518 BC, the capital of the Achaemenid Empire. SOURCE: UNESCO.

Pharaoh → The ruler of Ancient Egypt.

Qajar Dynasty → 1789–1925.

Qameh Zani → A form of ritual bloodletting, practiced as of act of mourning by Shia Muslims (it is forbidden according to most Grand Ayatollahs but not forbidden according to some [other] Grand Ayatollahs) for the younger grandson of the Prophet Mohammad, Husayn (Hossein) ibn Ali, who was killed along with his children, companions, and near relatives at the Battle of Karbala by the Umayyad caliph Yazid I.

Reza, Emam ('Alī al-Reżā, Abu'l-Ḥasan bin Mūsā bin Ja'far) → The eighth Emam of the Emāmī Shi'ites. In Shi'ite sources he is commonly referred to as Abu'l-Ḥasan al-Ṯānī in order to distinguish him from his father, Emam Mūsā al-Kāẓem, who is known as Abu'l-Ḥasan al-Awwal. He was born and grew up in Medina. The year of his birth is variously given as 148/765, 151/768, and 153/770.

He was made crown prince by Caliph Al-Ma'mun and famous for his discussions with both Muslim and non-Muslim religious scholars.

According to Shia sources, he was poisoned in Mashhad, Iran, on the order of Caliph Al-Ma'mun. Buried in the Emam Reza shrine in Mashhad, Iran.

Rowzeh Khani → One of the most important rituals that became popular during the Safavid period, a ritual sermon recounting and mourning the tragedy of Karbala. SOURCE: THE UNIVERSITY OF TEXAS PRESS.

Safavid dynasty (era) → 1501–1722.

Sagga Khaneh (Saghah Khaneh) → Public water fountain.

Sanghar/Songhar → Turkish speaking tribes that live around Kermanshah. SOURCE: WILLEM FLOOR, *KERMANSHAH CITY AND PROVINCE 1800–1945, P. 182.*

Sardari → Old fashion frock pleated around the waist. SOURCE: PERSIAN-ENGLISH DICTIONARY.

Sassanid Dynasty (era) → 224–651.

Scarce, Jennifer M. → Prominent scholar, writer, and pioneer who wrote extensively about Qajar tile works. Articles she has written over the years:

"Ali Mohammad Esfahani, a tile maker of Tehran," *Oriental Art*, new series, vol. 22, no. 3, 1976, pp. 278–288; this article also describes how Mohammad Ali Esfahani befriended the British engineer Robert Murdoch Smith, a well-known collector of Persian art, especially tiles.

"The Architecture and Decoration of the Gulistan Palace: The Aims and Achievements of Fath' Ali Shah (1797–1834) and Nasir al Din Shah (1848–1896)," *Iranian Studies*, vol. 34, nos. 1–4, 2001.

"Function and Decoration in Qajar Tile work," in *Islam in the Balkans: Persian Art and Culture of the 18th and 19th Centuries* (Royal Scottish Museum Edinburgh, 1979).

Shafaat → Intersession mediatory. SOURCE: PERSIAN-ENGLISH DICTIONARY.

Sharbat → A sweet drink.

Shiraz → Name of a province and a town in southern Iran.

Sineh Zani → Chest beating ritual performed by Shia Muslims while mourning for Emam Hossein during the month of Moharram. See also Chest beating.

Soleiman, King (Solomon, Hazrat Soleiman, Sulayman, Salomon) → Also called Jedidiah (Hebrew יְדִידְיָה *Yedidyah*) and according to the Hebrew Bible or Old Testament, Quran, and Hadiths a fabulously wealthy and wise king of the United Kingdom of Israel who succeeded his father, King David. The conventional dates of Solomon's reign are around 970 to 931 BC, normally given in alignment with the dates of David's reign. He is described as king of the United Monarchy, which broke apart into the northern Kingdom of Israel and the southern Kingdom of Judah shortly after his death. Following the split, his patrilineal descendants ruled over Judah alone. According to the Talmud, Solomon is one of the 48 prophets. In the Quran, he is considered a major prophet, and Muslims generally refer to him by the Arabic variant Sulayman/Soleiman, son of Dawud/Daud (سُلیمان بن داود).

Taq-e Bostan (Persian: طاق بستان) → Meaning "arch of the garden" or "arch made by stone," a site with a series of large rock reliefs from the era of the Sassanid Empire of Persia (Iran), carved around the 4th century AD (near the city of Kermanshah).

Tazzieh (Taziya, Ta'zia, Ta'zieh) → Primarily known from the Persian tradition, it is a Shi'ite Muslim ritual that reenacts the death of Hossein (the Islamic Prophet Mohammad's grandson) and his male children and companions in a brutal massacre on the plains of Karbala, Iraq, in the year AD 680. His death was the result of a power struggle in the decision of control of the Muslim community (called the caliph) after the death of (Prophet) Mohammad.

Tchop Sangi → Stone lithography.

Tekkieh Manuchehri → A Tekkieh (religious building) located in Tehran.

Tile-making process → Involves the works of the kashisab (tile grinder/grater), the gholebkar (tile molder), the naghash (tile designer), and the kourehban (kiln supervisor).

Youssef (Yusof, Joseph) → The story of Joseph is described in the Quran (12.3) as the most beautiful of stories (*aḥsan al-qeṣaṣ*). As a graphic romance of love and adversity, of an innocent boy of incomparable beauty sold into slavery by his own brothers, his rise as a righteous young man from unjust imprisonment

to the highest office in Egypt, his wisdom in running the state affairs, and his generous reconciliation with his brothers has always been a source of attractive subject matter for the exegetists of the Quran, poets, miniaturists, and popular tales. The most appealing subject from the Joseph story is the episode involving Potiphar's wife, called Zolaykā in Islamic lore. The popularity of the stories about Zolay-kā's love for Joseph as a subject for lyrical and narrative poetry dates back to the Ghaznavid period. The definitive development affecting the portrayal of Joseph in the Qajar period is its inclusion, along with heroes of the *Šāh-nāma* and the martyrs of Karbalā, in what is commonly referred to as the Coffee House paintings. This trend in painting continues, mostly on canvas, to the present day. SOURCE: ENCYCLOPEDIA IRANICA.

Joseph was appointed head of Potiphar's estate. However, this would not last for long.

Attracted by his handsome looks, Potiphar's wife desired to be intimate with him. To her consternation, Joseph continuously refused. One day, when no one was home other than the two of them, the mistress grasped Joseph's garment, demanding that he consent. Thinking quickly, Joseph slid out of his cloak and ran outside. This self-control earned him the appellation "Joseph the righteous."

But Potiphar's wife turned the tables on Joseph, telling her husband that it was Joseph who had tried to entice her. The angry master reacted by placing his trustworthy assistant in prison. SOURCE: *YEHUDA ALTEIN, THE STORY OF JOSEPH IN THE BIBLE: FROM PRISONER TO PRINCE.*

Zand, Karim Khan (AD 1751–1779) → Founder of the Zand Dynasty who ruled from the city of Shiraz.

Zangeneh, Zahir ol Molk → Military commander of the Kermanshah region during the time of Mohammad Ali Shah Qajar (r.1907–1909) who was in charge of the reactionary forces that destroyed the Tekkieh Moaven and the Moaven ol Molk's house.

Zeynabieh (Zaynabieh) → One of the buildings in Tekkieh Moaven dedicated to Zeinab, the granddaughter of the Prophet Mohammad.

Zur Khaneh → Gymnasium where participants practice traditional wrestling.

Selected Dynasties

Qajars (1794–1925)

Agha Mohammad Khan	1794–1797 (initially ruler in northern and Central Iran; from 1794 ruler of all Iran)
Fath Ali Shah Qajar	r.1794–1838
Mohammad	r.1834–1848
Nasir al Din	r.1848–1896
Mozaffer al Din	r.1896–1907
Mohammad Ali	r.1907–1909
Ahmad	r.1909–1925

Pahlavis (1925–1979)

Reza	r.1925–1941
Mohammad Reza	r.1941–1979

About the Author

Hadi Seif was born in 1948 in Shiraz, Iran, where he spent his high-school years. He studied art history at the University of Isfahan. His bachelor's thesis was titled "The Role of Turkmen in Western Asia" and his master's thesis "The Timurids and the Artistic Evolution of the Shiraz School." He went on to study at the University of Strasbourg, where he defended his dissertation entitled "The Role of Mythical Animals in the Carvings of Persepolis." He taught several Iranian popular art courses to post-graduate and doctoral students at the Academy of Arts in Tehran. Over the years, he has published more than 80 books, mainly related to Persian popular arts, and has also produced several television documentaries on the subject. He is currently a senior researcher of Iranian arts. Hadi Seif's research work in the field of traditional arts include books on Coffee House paintings, paintings on tiles, paintings on plaster, and paintings behind glass.

He has a charming and easy going pen for the subjects he writes about.

He is also the author of *Persian Painted Tile Work from the 18th and 19th Centuries: The Shiraz School*, published in 2014 by Arnoldsche, Germany. This book was also translated and sponsored by Hamid Kooros and Texas General Financial Corporation.

Acknowledgments (in alphabetical order)

MIRO DVORSCAK

We thank Miro Dvorscak for his help with the initial layout of the book, text formatting, and image editing.

AIMEE FROOM

PhD, curator of *Art of Islamic Worlds*, The Museum of Fine Arts, Houston.
We thank Aimee Froom for reviewing the manuscript and for giving us valuable comments and suggestions on it.

HAMID KOOROS

We thank Mr. Hamid Kooros for the generous financial support he provided for the publication of this book. In addition, Mr. Kooros coordinated the whole project; he also translated the original Persian text provided by Hadi Seif into English and worked on some of the glossary entries.

SAEED KOUROS

We thank Mr. Saeed Kouros for providing us with some of the historical background to the events related to this book.

MEHDI TAEI

We are grateful for all the help Mehdi Taei provided in organizing different activities for this book, including photocopying and transferring texts and images.

Hosseinieh

Zeynabieh

Hammam

(public bath)

Abbassieh

ABOVE Tekkieh Moaven ol Molk Ground Plan

EDITOR
Hamid Kooros

AUTHOR
Hadi Seif

TRANSLATION
Hamid Kooros

GRAPHIC DESIGNER
Karina Moschke, Kirchheim/Teck

OFFSET REPRODUCTIONS
Paladin Design- und Werbemanufaktur, Remseck

PRINTED BY
Schleunung Druck, Marktheidenfeld

BOUND BY
Hubert & Co., Göttingen

PAPER
Magno Satin 150 g/qm

ARNOLDSCHE PROJECT COORDINATION
Isabella Flucher, Julia Hohrein

BIBLIOGRAPHIC INFORMATION
PUBLISHED BY THE DEUTSCHE NATIONALBIBLIOTHEK
The Deutsche Nationalbibliothek lists this publication in the
Deutsche Nationalbibliografie; detailed bibliographic data are
available at www.dnb.de.

ISBN 978-3-89790-668-6

Made in Germany, 2022

PHOTO CREDITS
All color photos are credited to Soheil Ghanbarzadeh.
Black-and-white images photographed during the 1960s in this book
were taken by an unknown photographer.

COVER ILLUSTRATIONS
front: Detail of geometric tile design (Abbassieh).
back: View of the entry portal (Hosseinieh).

Illustration on p. 2: Floral tile design with birds.
Illustration on p. 5: Geometrical and floral tile design.
Illustration on p. 7: Stylized detail of lion heads, birds, grapes,
and vines.